Passionate Observer:
Eudora Welty

AMONG ARTISTS OF THE THIRTIES

René Paul Barilleaux, Editor

Essays by

Suzanne Marrs

Patti Carr Black

Francis V. O'Connor

MISSISSIPPI MUSEUM of ART
THE ANNIE LAURIE SWAIM HEARIN MEMORIAL EXHIBITION SERIES

Passionate Observer: Eudora Welty among Artists of the Thirties is published on the occasion of an exhibition of the same title organized by Patti Carr Black and René Paul Barilleaux for the Mississippi Museum of Art, Jackson, April 6 – June 30, 2002, assisted by Robin C. Fortenberry.

The Mississippi Museum of Art gratefully acknowledges the support of the Robert M. Hearin Foundation, without which this book and the *Passionate Observer* exhibition would not have been possible.

The Mississippi Museum of Art and its programs are sponsored in part by the city of Jackson; The ArtsAlliance of Jackson & Hinds County; the Mississippi Arts Commission; and the National Endowment for the Arts, a federal agency funding statewide programs.

Library of Congress Cataloging-in-Publication Data

Welty, Eudora, 1909
 Passionate observer : Eudora Welty among artists of the thirties / René Paul Barilleaux, editor ; essays by Patti Carr Black, Suzanne Marrs, Francis V. O'Connor.
 p. cm.
 "Published on the occasion of an exhibition of the same title organized ... for the Mississippi Museum of Art, Jackson, April 6- June 30, 2002"--T.p. verso.
 Includes bibliographical references.
 ISBN 1-887422-06-4 (alk. paper)
 1. Photography, Artistic--Exhibitions. 2. Welty, Eudora, 1909 ---Exhibitions. I. Barilleaux, René Paul. II. Mississippi Museum of Art. III. Title.

TR647 .W423 2002
779'.092--dc21
 2002019832

Copyedited by Kathy L. Greenberg
Designed by Heidi Flynn Allen, Flynn Design
Printed in Canada by Friesens
Second printing, 2003

Title pages: Portrait of Eudora Welty, 1930s. Courtesy of James Patterson, Jackson, Mississippi.

Acknowledgments

One of the great joys of working as director of an art museum is the privilege of being involved with projects like *Passionate Observer: Eudora Welty among Artists of the Thirties*. Since 1992 the Hearin family in Jackson, Miss., has generously honored the memory of their mother through The Annie Laurie Swaim Hearin Memorial Exhibition Series. The series has brought to Mississippi remarkable artwork from around the world and offered our citizens the opportunity to encounter world masterpieces firsthand.

For the first time this series not only brings great artwork *to* Mississippi, it also holds up the important artwork *of* Mississippi by focusing on the visual art of Eudora Welty and her contemporaries. This book and the exhibition held at the Mississippi Museum of Art in 2002 has special significance because Mrs. Hearin was friends and contemporaries with Miss Welty and the other artists featured here.

The genesis of this particular project was the generous gift of eighteen photographs by Eudora Welty to the Museum by AmSouth Bank. Many others have generously provided materials to complement the Welty photographs in both this book and exhibition.

The people of Mississippi deeply love and revere Miss Welty for her work. Likewise, Mississippians lead the many throughout the world who add to the scholarship about her literature and photography. We are grateful to Suzanne Marrs, Patti Carr Black, and Francis V. O'Connor for contributing their knowledge to this volume. Also, to Miss Welty's friends and colleagues who have advised us on this project since its inception, we are especially grateful: Hunter Cole, Donna Dye, Seetha Srinivasan, and Miss Welty's nieces—Mary Alice Welty White and Elizabeth Welty Thompson—for their care, thoughtfulness, and helpfulness. Further, the guardians of Miss Welty's archives at the Mississippi Department of Archives and History here in Jackson, Hank Holmes and Forrest Galey, have been tremendously helpful in facilitating the use of the artist's images.

Finally, I thank my colleagues at the Mississippi Museum of Art. Jane Crater Hiatt, former interim director of the Museum, led the project for several months. Robin C. Fortenberry ably assisted the curators as they identified and gathered materials for this book and artwork for the exhibition. And, finally, René Paul Barilleaux's keen intellect, fine eye, and thoughtful preparation have guided and shaped the integrity and quality of this entire project. With the fine design work by Heidi Flynn Allen and copyediting by Kathy L. Greenberg, a volume has been produced that we hope will bring you many hours of learning, delight, and surprise.

Our thanks to all who have helped us to understand Mississippi's most beloved writer as an important visual artist with a vision all her own.

Betsy Bradley

Passionate Observer: Eudora Welty among Artists of the Thirties is the sixth presentation in a series presented by the Mississippi Museum of Art and the Robert M. Hearin Foundation to honor the memory of Annie Laurie Swaim Hearin.

Mrs. Hearin was born and educated in Alabama but spent her adult life in Jackson, devoting herself to her family and her community. She was active in many community organizations, including serving as president of the Junior League of Jackson. Mrs. Hearin found special satisfaction in her friends, family, and involvement in the Mississippi Museum of Art.

The impact of Mrs. Hearin's years of service has been far reaching. A generous contributor and trusted adviser, she served the Museum on its Board of Trustees and as president of its Gallery Guild. She was instrumental in the Museum's decision to establish a restaurant in its facility; not content to be an adviser and policy setter, Mrs. Hearin contributed many, many hours supporting the restaurant as a waitress and as day chairman of the volunteers until her death. She and her husband, Robert M. Hearin (now deceased), were also critical in the founding of the Impressions Gallery, a hands-on gallery for young people at the Museum. In addition, Mrs. Hearin helped establish the Mississippi Museum of Art Foundation, Inc., acting as a charter member of its board. Her concern for the Museum was not only for strong programming, but also for its long-term health and its potential to benefit the community for many years beyond her life.

Her two children, Robert M. Hearin, Jr., and Annie Laurie Hearin McRee, continue the legacy begun by their mother and are active supporters of the Museum. Previous exhibitions in The Annie Laurie Swaim Hearin Memorial Exhibition Series include *Dutch and Flemish Seventeenth Century Paintings: The Harold Samuel Collection*, *Edgar Degas: The Many Dimensions of a Master French Impressionist*, *Italian Paintings from Burghley House*, *Our Nation's Colors: A Celebration of American Painting*, and *The American West: Out of Myth, Into Reality*.

The Mississippi Museum of Art is grateful for the life of Mrs. Hearin, the example she left for us all, and the Robert M. Hearin Foundation's generosity in establishing this series for the enjoyment of generations to come.

Photographs by Mississippi icon Eudora Welty capture in pictures the world this beloved author also described with words. The impact of Welty's images and the clarity of her artistic vision have yet to be examined within the context of American art of the 1930s. This book, together with an exhibition of the same title presented at the Mississippi Museum of Art in 2002, places Welty's photographs from the thirties alongside visual artwork by her contemporaries from across the country. Here, Eudora Welty is appreciated not just for her prose or her photographs. Rather, the photographs—like the works by painters and sculptors of the period—are understood as visual interpretations of the artist's world. They offer insight into the way Welty saw life around her, how she felt about what she saw, and what she cared about most. Both a compassionate observer of the world and a passionate image maker, Eudora Welty was a visual artist who used the camera much like she used language when working as a writer.

The following essays attempt to deepen our understanding of Eudora Welty's interest and aspirations in photography. Authored by specialists in their respective areas, these essays place Welty's photographs within the broader context of the Great Depression. This exploration begins with noted Welty scholar Suzanne Marrs's investigation of the intersection of Welty's fiction and photographs, followed by Patti Carr Black's discussion of Mississippi and southern artists central to the period. Marrs, a professor at Jackson's Millsaps College, and Black, former director of the Old Capitol Museum, Mississippi Department of Archives and History, also in Jackson, were both close personal friends of Welty. Francis V. O'Connor, an independent historian of American art and a specialist on New Deal art programs of the 1930s, broadens this research by examining relationships between Welty and Mississippi, southern, and American art of the era.

It is nearly impossible to separate any discussion of Eudora Welty as a writer and a visual artist from her life in Mississippi. A southern sense of place pervades everything she made, and it is through her words and pictures that one shares in Welty's celebration of her home and her people. Although these photographs were made during a period of widespread economic instability and often great personal despair, they evidence Welty's optimism about the human spirit and pride in her native state. Eudora Welty, perhaps more than any other artist working during the Great Depression, was the ultimate passionate observer of her times.

René Paul Barilleaux

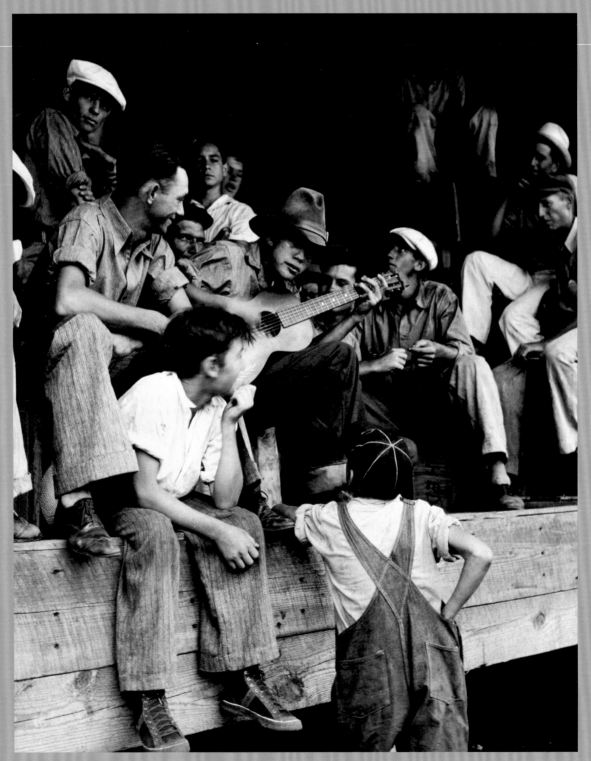

Eudora Welty, *Tomato packers' recess, Crystal Springs*, 1935-1936. Eudora Welty Collection – Mississippi Department of Archives and History.

Eudora Welty's Enduring Images: Photography and Fiction

BY SUZANNE MARRS

MY WISH, INDEED MY CONTINUING PASSION, WOULD BE NOT TO POINT THE FINGER IN JUDGMENT BUT TO PART A CURTAIN, THAT INVISIBLE SHADOW THAT FALLS BETWEEN PEOPLE, THE VEIL OF INDIFFERENCE TO EACH OTHER'S PRESENCE, EACH OTHER'S WONDER, EACH OTHER'S HUMAN PLIGHT. [1]

A native and lifelong resident of Jackson, Miss., Eudora Welty grew up with photography. Her father, who "loved all instruments that would instruct and fascinate," especially loved the camera.[2] He used one to document his travels, to capture images of his wife, and to record the lives of his children. From the cradle, then, Welty was photographed, and in due time she herself became a photographer, making her own prints in a jerry-rigged darkroom.

Welty and her Jackson friends found the camera to be a source of great fun. They photographed each other in amusing and satiric poses, with Welty often the photographed rather than the photographer. One image shows Welty seated in front of a mirror applying everything but make-up to her face. Another depicts her lifelong pal Frank Lyell in sombrero serenading a disdainful Welty who is clad in a Spanish shawl. Even as she used the camera for entertainment, Welty began around 1929 to think of photography in more aesthetic terms. Using a Kodak camera with a bellows, she snapped images of Mississippians and Mississippi life. As photography became increasingly important to her, she first purchased a Recomar and then a Rolleiflex camera. With these more sophisticated instruments, she expanded her range, photographing her travels to Charleston, New York, and Mexico, in addition to documenting the variety of her home state.

For Welty in the 1930s, photography was an artistic endeavor, one she thought might become the method by which she would earn a living. In 1933 she and Hubert Creekmore, a novelist and poet whose sister would marry Welty's brother Walter, busied themselves taking pictures for the Jackson Junior Auxiliary, though such work proved boring. In 1936 Welty applied for a photographer's position with the Resettlement Administration, but had to remain content with what would prove a short-lived job as junior publicity agent for the Works Progress Administration (WPA) and with taking occasional photographs to publicize WPA projects. Such work was often tedious and unfulfilling. "Let me know when you expect to come to Jackson," she wrote Lyell, who that summer was working on his Ph.D. at Princeton, "so I can plan not to be in Noxapater photographing a cold storage plant." By 1937, however, magazine publication of her

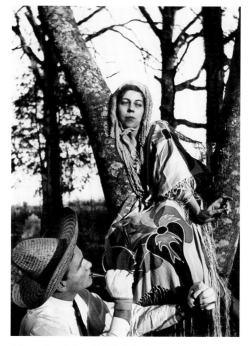

Unknown, *Serenade, Annandale*, 1930s. Eudora Welty Collection – Mississippi Department of Archives and History.

Unknown, *Helena Arden*, 1930s. Eudora Welty Collection – Mississippi Department of Archives and History.

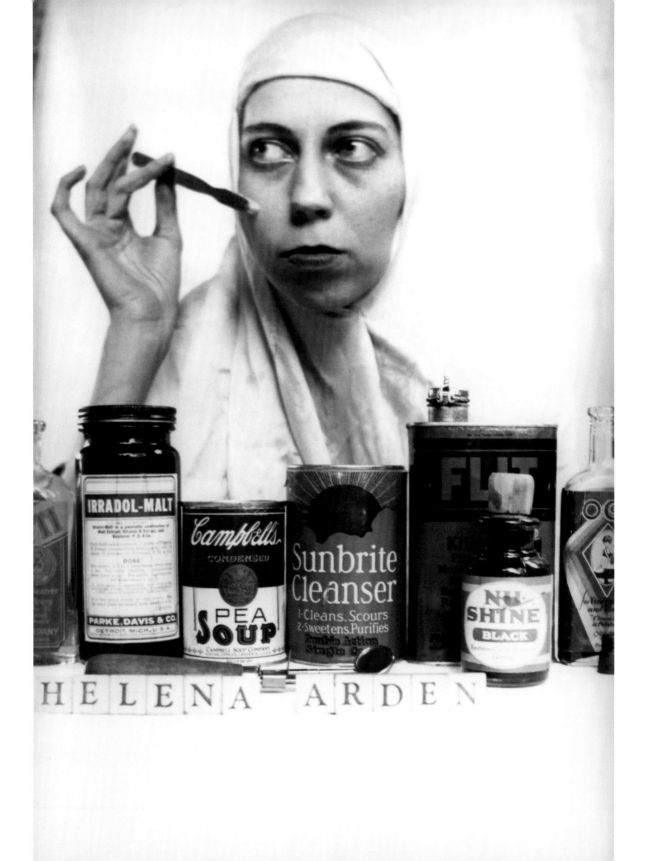

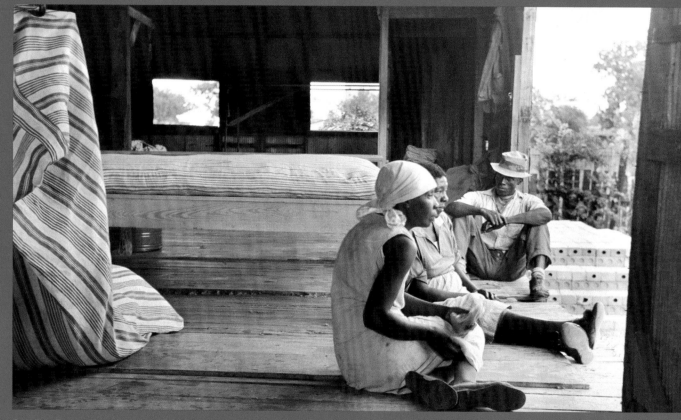

Eudora Welty, *The mattress factory, Jackson*, prior to 1935. Eudora Welty Collection – Mississippi Department of Archives and History.

photographs seemed promising. *Life*, after rejecting her tombstone prints and what editor Frank Hall Fraysur called her "Negro Holiness Church story," published six Welty photographs in its November 8, 1937, issue and another in its January 17, 1938, issue. These images documented the tragic story of a Mt. Olive, Miss., doctor and the campaign against tuberculosis by another Mississippi physician.[3]

Welty's real interest, however, was not in such commissions, but in a freer and more artistic attempt to reveal the nature and variety of life in her native state. By 1934, having seen and disliked the book *Roll, Jordan, Roll*, which contained Doris Ulmann's sentimental photographs of African Americans, Welty had prepared a book of her own. Creekmore urged her to wait before showing it to publishers—he wanted her to include photographs of a ball game and a baptizing. But early in 1935, Welty rejected the notion of delay: "I am afraid somebody else will get out something like it or the publishers or the public will become saturated with photography books."[4] She hoped to make enough money on the volume she called "Black Saturday" to finance a future book on either Mexico or Alaska, and for the next three years she tried without success to locate a publisher. She also sought to pair photographs with some of the first stories she had written, thinking that the photographs might create a market for the stories—they did not. Nevertheless, Welty continued to take photographs throughout the thirties. Whether she was working at WJDX radio station, promoting the Works Progress Administration, or producing stories for the Mississippi Advertising Commission, Welty took photographs for her own interest and pleasure in addition to taking the mundane pictures required for her jobs.

The photographs she took as an artist rather than a journalist or publicist resulted in two New York City exhibitions. In 1936 forty-five Welty photographs constituted a one-woman show at Lugene Opticians' Photographic Galleries. These images primarily depict black life in Mississippi. They show women in long dresses and in men's hats strolling through town, church members displaying the costumes they have made for a bird pageant, the dappled light surrounding a washwoman who is taking a break, workers in Jackson's new mattress factory, two young black girls carrying their white dolls, a couple in

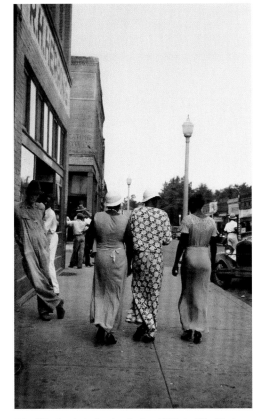

Eudora Welty, *Saturday Strollers, Grenada*, prior to 1935. Eudora Welty Collection – Mississippi Department of Archives and History.

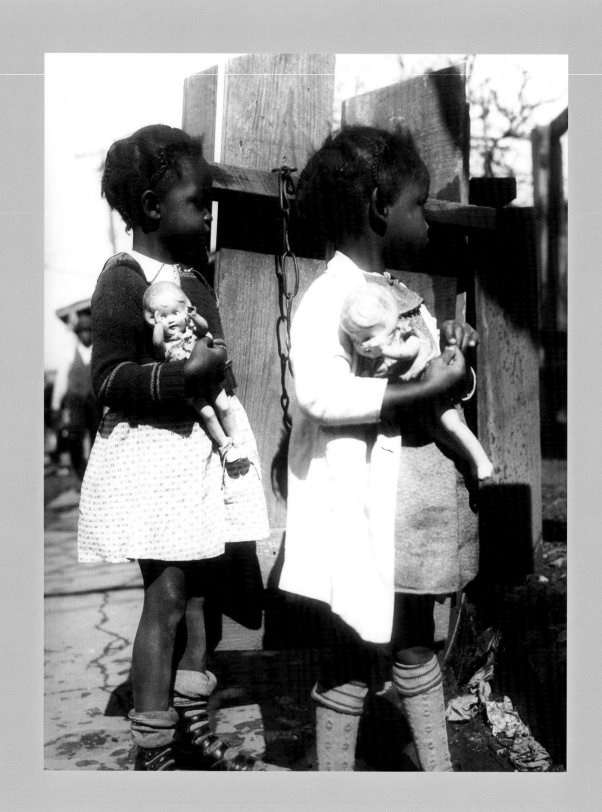

Eudora Welty, *Dolls, Jackson*, 1935-1936. Eudora Welty Collection – Mississippi Department of Archives and History.

tattered clothes making a date, and a schoolteacher who is window shopping. Unlike Ulmann's photographs, these images do not romanticize faithful retainers in a paternalistic system. Instead, Welty shows the poverty that afflicts individuals, the white icons given to black children, the exhausting work that is the weekday lot of the washwoman and the factory workers, and the resilient spirit that, in the face of straitened circumstances, typified life in Mississippi.

In writing her stories of the thirties, Welty never consulted her photographs of black life in Depression-era Mississippi, but her stories focusing upon black characters show the empathy that was present in the photographs. Toni Morrison has observed that Welty wrote "about black people in a way that few white men have ever been able to write. It's not patronizing, not romanticizing—it's the way they should be written about." In "Powerhouse," for instance, Welty based the African American pianist who "gives everything" as he performs not only upon Fats Waller, but also upon her own experience of being driven by "the love of her art and the love of giving it, the desire to give it until there is no more left." Similarly, in "A Worn Path" Welty's own love of family emerges in the life of Phoenix Jackson. Black, old, infirm, and her memory beginning to fail, Phoenix makes a heroic journey to obtain medicine for her grandson; the "deep-grained habit of love" elevates her above the white characters who pity and patronize her.[5] Clearly, Welty created both Powerhouse and Phoenix out of her own inner life, and in doing so she achieved in writing what she had achieved in her snapshots: a bridge across the racial gap that was so dominant a part of Mississippi culture.

Welty's second photographic exhibition took place in March 1937; Samuel Robbins, who had worked for Lugene Opticians, wrote to Welty on behalf of his new business, The Camera House, and asked for a show of "poor white" photographs. It is unclear exactly what images were part of that show, but correspondence indicates that Welty included some of her church-yard photographs and pictures of white Mississippians. In her work as a writer, Welty certainly was concerned with the plight of poor, white Mississippians, and she grants such characters the same individuality, complexity, and humanity she had established in her black protagonists. In "The Whistle" Jason

and Sara Morton, a poor tenant farming couple, battle desperation and alienation as they defy the forces of man and nature that constrict their lives. Having covered their plants with all of their clothes and bedclothes, they then attempt to keep themselves warm by burning their last log and ultimately their few pieces of furniture. In "Death of a Traveling Salesman" a young couple, too poor to afford even matches, still manage to share a vital, fruitful relationship and seem to represent "some ancient promise of food and warmth and light."[6]

The tombstone photographs included in this second show seem removed from the exhibition's main theme, but they are not removed from Welty's central concerns as a photographer and a fiction writer. "In the most unpretentious snapshot," Welty wrote, "lies the wish to clasp fleeting life. Framing a few square inches of space for the fraction of a second, the photographer may capture—rescue from oblivion—fellow human beings caught in the act of living. He is devoted to the human quality of transience."[7] The many cemetery photographs are eloquent testimony to that same quality of transience and to the same need to rescue human life from oblivion. Time moves inexorably and life is short, Welty's cemetery photographs tell us. One of her earliest stories, "Magic," set in a Jackson cemetery beneath a cemetery angel that Welty had photographed, conveys a similar message. Here, a young girl is seduced; here, she becomes a victim of her own illusions about love and is introduced to the reality of time's movement. The story, like a snapshot, frames a moment in time as it depicts the innocence that is inevitably lost to time.

Though Welty managed to include her graveyard photographs in her second show, she was evidently not able to include her photographs of New York City. Having been a graduate student at Columbia University in 1930-1931 and having regularly returned to New York to visit friends, take advantage of cultural opportunities, and seek publication of her fiction and photographs, Welty knew the city well. Her pictures of Manhattan at times present the beautiful patterns of light and dark that play about the city's elevated trains and the stairways to them. One recalls Gerard Manley Hopkins's exclamation, "Glory be to God for dappled things." But then these "dappled things" are made of concrete and steel and seem at once glorious and alien.

Eudora Welty, *Untitled. Cemetery angel, "Ellen Moore,"*
Jackson's Greenwood Cemetery, 1935-1936. Eudora Welty Collection –
Mississippi Department of Archives and History.

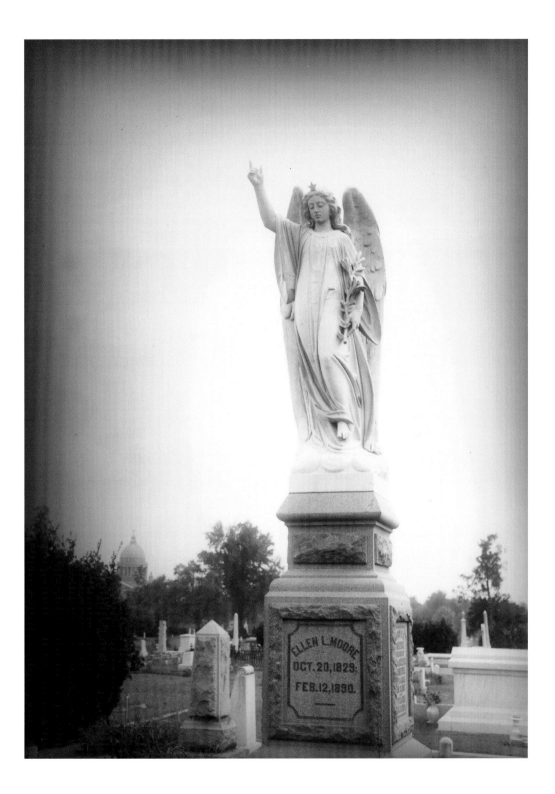

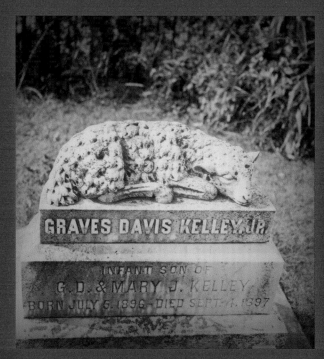

Eudora Welty, *Untitled. Cemetery lamb, Utica*, post 1936. Eudora Welty Collection – Mississippi Department of Archives and History.

Eudora Welty, *Untitled. Cemetery monument, "He was an honor to the earth on which he lived."*
Utica, post 1936. Eudora Welty Collection – Mississippi Department of Archives and History.

Other New York pictures are less affirmative in impact. They depict rather ordinary looking people who, during conventional business hours, sit on Union Square park benches or gather for protests because they have no jobs to occupy their days and provide them with purpose and sustenance. These photographs seldom focus upon a single face as Welty's Mississippi photographs often did, but instead depict numerous individuals who are typically overshadowed by massive city buildings.

Perhaps Welty did not feel comfortable enough to take informal portraits. Or, as is more likely, perhaps she sensed that the impersonal, concrete-and-steel world of the city in some sense contributed to the suffering she saw around her. Of course Welty had seen plenty of poverty in Mississippi during her 1936 stint with the WPA. Her Mississippi photographs show people in patched and ragged clothes, people looking longingly in store windows, people living in unpainted shacks with rotting porches. At times they also show, to use Harriet Pollack's words, individuals who are "spatially overmatched," who seemed dwarfed by their setting and circumstances. But the more temperate climate of Mississippi and the possibility that one might be able to plant a garden, own chickens, maybe have a cow even in town—these factors meliorated to some extent the effects of poverty in an essentially rural southern state. So too did the smallness of Mississippi's population. As Welty writes in the introduction to *One Time, One Place*: "In New York there had been the faceless breadlines; on Farish Street in my home town of Jackson, the proprietor of the My Blue Heaven Café had written on the glass of the front door with his own finger dipped in window polish: 'AT 4³⁰ AM WE OPEN OUR DOORS. WE HAVE NO CERTAIN TIME TO CLOSE. *The* COOK WILL BE GLAD *To* SERVE U. WITH A 5 *And* 10¢ STEW.' The message was personal and particular. More than what is phenomenal, that strikes home. It happened to me everywhere I went, and I took these pictures." Everywhere in Mississippi, that is.

It did not happen everywhere in New York City, and Welty's relatively faceless pictures of the city's unemployed people suggest the anonymity, the lack of connection they faced in the city. As Welty told interviewers Hunter Cole and Seetha Srinivasan in 1989, "These people of the Great Depression kept alive on the determination to get back to work and to make a

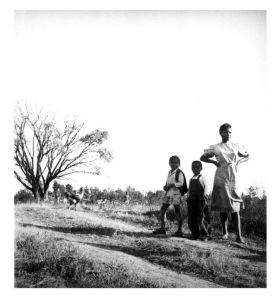

Eudora Welty, *Too far to walk it, Star*, post 1936. Eudora Welty Collection – Mississippi Department of Archives and History.

Eudora Welty, *My Blue Heaven Café, Jackson*, 1935-1936. Eudora Welty Collection – Mississippi Department of Archives and History.

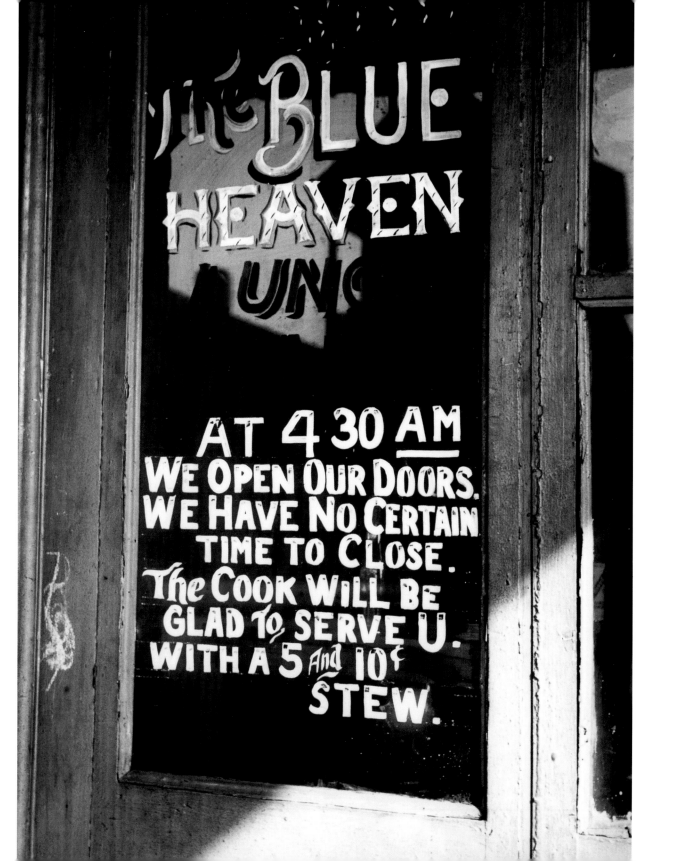

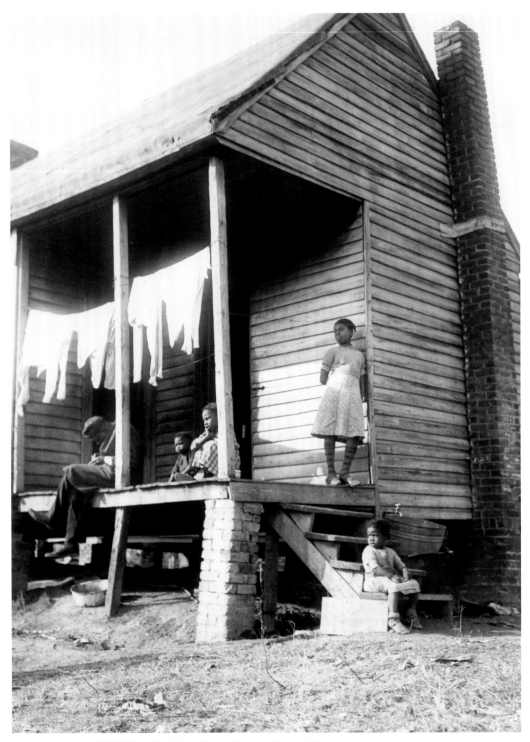

Eudora Welty, *Home, Jackson*, 1935-1936. Eudora Welty Collection – Mississippi Department of Archives and History.

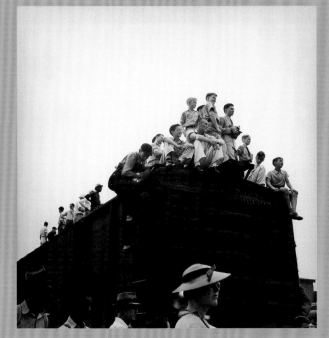

Eudora Welty, *Here it comes! Crowd on a boxcar, watching a circus being unloaded, Jackson*, post 1936.
Eudora Welty Collection – Mississippi Department of Archives and History.

living again. I photographed them in Union Square and in subways and sleeping in subway stations and huddling together to keep warm, and I felt, then, sort of placed in the editorial position as I took their pictures. Recording the mass of them did constitute a plea on their behalf to the public, their existing plight being so evident in the mass."[8] The same city that offered the relatively affluent Welty a vital personal and cultural life, denied others both the physical and emotional means to exist.

Welty's New York photographs come directly into one story of the thirties. But in her story those images are transformed and transfigured. As Welty told Hermione Lee, "I had to go on to fiction from photographing. That's the only way you can really part the veil between people, not in images but in what comes from inside, in both subject and writer." The story "Flowers for Marjorie" offers a prime example of the transformation of photographic vision into fiction. In this story Welty has drawn upon memories of several scenes she had captured with her camera, memories of an elevated train, of Union Square seen from various angles, and of protest demonstrations. But one photograph of Union Square includes especially suggestive images: a clock on the left below the center of the photograph and another at the upper right, a National Recovery Administration (NRA) Code sign in the upper center, the Union Square Savings Bank in the center, and unemployed men and women across the foreground. Each of these details suggests an aspect of "Flowers for Marjorie." This is a story about time. For Howard who, with his wife Marjorie, has come to New York from Victory, Miss., time seems to have stopped. Though his wife is pregnant and serene in her fruitfulness, Howard is tormented by his inability to find work and to provide for his wife and the child she assures him will come. And when Marjorie fails to understand his desperation, he attacks her verbally: "'Just because you're going to have a baby, just because that's a thing that's bound to happen, just because you can't go around forever with a baby inside your belly, and it will really happen that the baby is born—that doesn't mean everything else is going to happen and change!'"[9] For Howard time has stopped; the fact that it has not stopped for Marjorie seems to mark his personal failure. For that reason, in what seems a fantasy to him, he moves beyond verbal attacks and seeks to remove the source of his guilt; he stabs Marjorie and

flings a "dreadfully" ticking clock out the window of his apartment. The clock in the story may well have been suggested by the framing clocks seen in the photograph, but only in the story can Welty offer her interpretation and show the image's impact upon her character: the movement of time stands in contrast to Howard's stagnating life.

The NRA Code sign and the unemployed individuals beneath it are two other images that in conjunction may have sparked Welty's imagination. Welty never calls the National Recovery Administration by name in "Flowers for Marjorie," but she does depict the response this program evoked from poverty-stricken individuals. By May 1935 when it was declared unconstitutional, the NRA had, despite the intentions behind it, seriously compromised the position of workers in America. Though industries under NRA protection from antitrust prosecution improved the economic situation and working conditions of some workers, they cut the income of others, laid off many more, and increased the prices of their goods. The implementation of government policy had intensified unemployment and economic need. In response, as David M. Kennedy has noted, "The curious passivity of the American people . . . was waning, yielding to a mounting sense of grievance and a restless demand for answers." In "Flowers for Marjorie" we see both the "curious passivity" and the "mounting sense of grievance." As Howard, at the story's beginning, sits in a row of unemployed men on a park bench, one of the men asks him, "'You goin' to join the demonstration at two o'clock?'" Howard is not going to, although Welty photographed just such a demonstration, a demonstration that might have been precipitated by the NRA Codes. "One of the modest, the shy, the sandy haired—one of those who would always have preferred waiting to one side," Howard cannot transcend passivity, cannot move forward in time, cannot demand answers, cannot join with others.[10]

Although Welty does not explicitly mention the NRA in "Flowers for Marjorie," she does mention another New Deal program, one established in April 1935 and one she endorsed. Over a year before she began working at the Jackson WPA and then writing this story, Welty took her Recomar photographs of New York City. And in "Flowers for Majorie" she has Howard

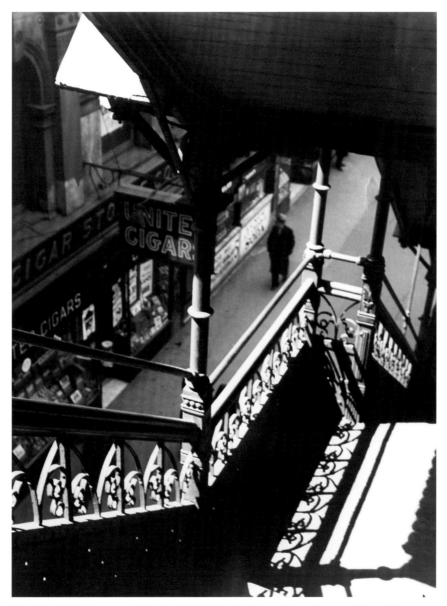

Eudora Welty, *Untitled. Outdoor stairway, New York City*, 1935-1936. Eudora Welty Collection – Mississippi Department of Archives and History.

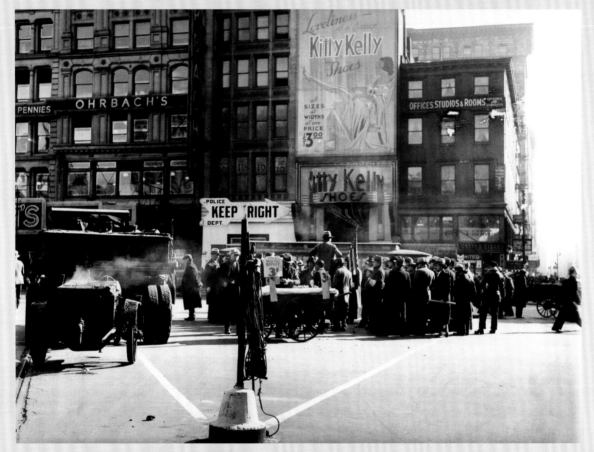

Eudora Welty, *Union Square, New York City*, 1935-1936. Eudora Welty Collection — Mississippi Department of Archives and History.

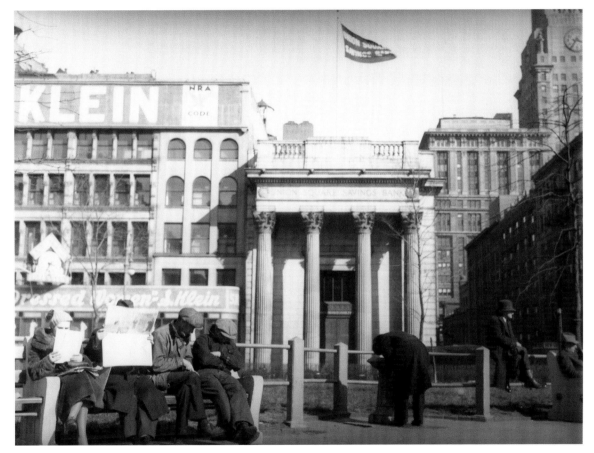

Eudora Welty, *The unemployed in Union Square, New York City*, 1935-1936. Eudora Welty Collection – Mississippi Department of Archives and History.

visit a WPA office in hopes of receiving comfort and under-standing, if not in hopes of finding a job. He goes to the office because that is the only place in New York City where some-one other than his wife knows him. But the WPA's Miss Ferguson thinks he is drunk, and she is far too busy to cope with him. Welty's pictures of a farm-to-market worker and a blind weaver for the WPA suggest that the sparsely populated world of Mississippi often allowed a more personal approach to poverty than the large city would permit. These people fill the frame of Welty's photographs; they are not overwhelmed by their setting or ignored by a besieged office worker.

One final image from the photograph conspicuously fails to appear in the story. The sight of the Union Square Savings Bank looming over the unemployed who have no financial resources would have been an appropriately ironic one. So too would the sense that the government in resolving the nation's banking crisis of 1932-1933 could not erase the difficulties of those whose money had been lost in bank failures or those who simply had no money to deposit. Still, Welty does not use this image. Her story is focused in the mind of Howard, and Howard as he sits on the Union Square park bench never looks up. In fact, two men in the photograph have their eyes downcast and their bodies slumped, in contrast to their park bench neighbors whose heads are buried deep in newspapers and who are perhaps searching the want ads, hoping for jobs. Howard, like the two slumping men, seems beaten. He cannot or will not look at the city around him, at a bank, or at other images of his own powerlessness. Though he might think of Marjorie's pregnancy as a mark of potency and renewal, he feels detached from it. And when he returns to their apartment and briefly embraces Marjorie, she tenderly regrets that "'We haven't been together in so long.'"[11] Sexually, financially, professionally, Howard at once feels impotent and seeks to repress that feeling.

Nowhere in this story is the New York that Welty loved. There are no art exhibitions, no theaters, no gatherings with friends. She shows a different side of the city here, one she had encountered as a photographer and was able to imagine as a writer. Her own privileged and secure existence made her very aware of those who had been denied such comfort,

and through fiction she was able to emphasize the psy-chological dimensions of visual images and to call implicitly for reform. This is not to say that Welty idealized the rural world of Mississippi or that she believed a place like Victory, Miss., would have inevitably saved Howard and Marjorie. Welty's story "The Whistle," as we have seen, describes the barren lives of a Mississippi tenant farming couple who are part of a one-crop, cash-crop system, who know the crippling effects of poverty, and who have experienced official insensitivity to their plight. In a sense, then, "Flowers for Marjorie" and "The Whistle" are companion stories, both describing the spiritual and material impact of the Great Depression as it spanned the nation from city to farm.

Though Welty as a fiction writer carefully selected her images to suggest the plight of Depression-era victims wherever they lived, she also sought to avoid propaganda or allegory and to admit into her stories the unknowable, incalculable aspects of human existence. In her photographs, individuals often stare not at the camera but toward the world outside of the picture's frame, and in fiction, as in photography, Welty sought to call our attention to the world beyond her frame. In "The Whistle," for instance, Welty shapes her story around a single evening's events, but she reminds us that other events and emotions lie beyond the story's bounds. She tells us that Mr. Perkins has been able to buy the Mortons' farm, but never tells us under what circumstances. She tells us that Jason and Sara Morton are alienated from each other, but offers only this explanation: "Perhaps, years ago, the long habit of silence may have been started in anger or passion. Who could tell now?"[12] Similarly, in "Flowers for Marjorie," Welty calls our attention to unanswered and potentially unanswerable ques-tions. Why have Howard and Marjorie moved to New York? Why don't they return home and wouldn't home provide some consolation? When did their emotional lives diverge and their ability to communicate cease? Much lies beyond the writer's frame and beyond any individual's ability to comprehend, and Welty as a writer wished to incorporate this mystery into her stories even as she confronted the social ills that plagued America in the 1930s.

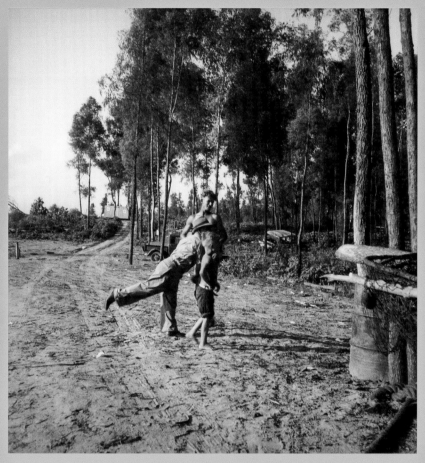

Eudora Welty, *Fisherman and his boys throwing knives at a target, near Grand Gulf*, post 1936. Eudora Welty Collection – Mississippi Department of Archives and History.

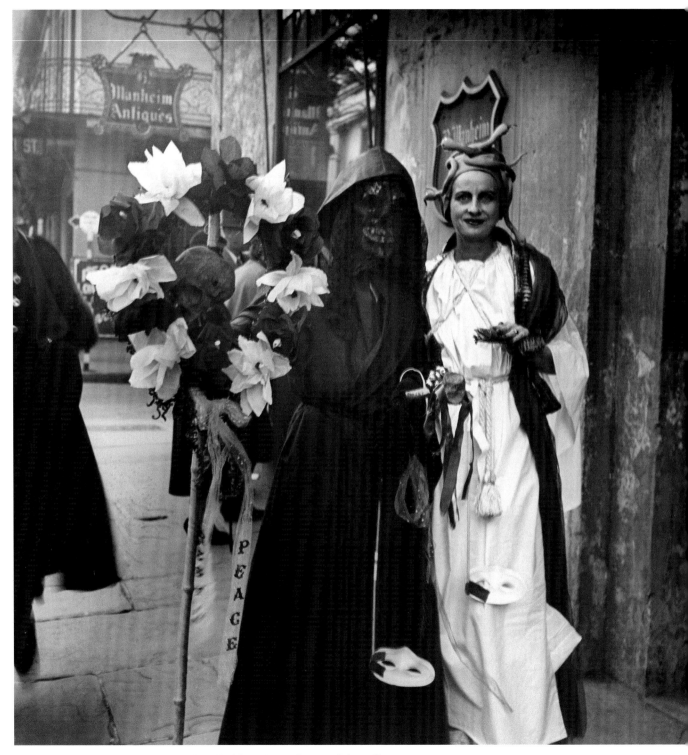

Eudora Welty, *Mardi Gras celebrations, New Orleans*, post 1936. Eudora Welty Collection – Mississippi Department of Archives and History.

By 1941 and the publication of her first book of stories, Welty's work as a photographer was largely behind her, but images from the thirties would continue to appear in her fiction and to be transformed into visual emblems of the emotions and feelings those stories address. Recalling the Mississippi River fishermen and shantyboats she had photographed, Welty would create the ominous setting of "At the Landing" (1943) where Jenny Lockhart realizes the destruction that may be implicit in daring. Recalling the tombstones she had photographed in Jackson, Crystal Springs, and Utica, Welty would create the cemeteries of *The Golden Apples* (1949) and *Losing Battles* (1970) and would thereby reinforce her thematic concern with mortality. And recalling a New Orleans Mardi Gras couple dressed as Death and Medusa, Welty would create the figures that Laurel and Fay must face in *The Optimist's Daughter* (1972) as they confront the death of father and husband. The images she saw through her camera's viewfinder were indelibly etched in her memory and would enrich her fiction long after her photographic activities had ceased. Welty's career as a photographer was regrettably short, but that short career helped to make Eudora Welty one of America's most distinguished writers of fiction, a writer with a storehouse of images through which she would for more than five decades part the metaphoric "curtain, that invisible shadow that falls between people, the veil of indifference to each other's presence, each other's wonder, each other's human plight."[13]

NOTES

1 Eudora Welty, et al., *One Time, One Place* (New York: Random House, 1971), 8.

2 Eudora Welty, *One Writer's Beginnings* (Cambridge: Harvard University Press, 1984), 3.

3 Eudora Welty, letter to Frank Lyell, August 11, 1936, cited by permission of Elizabeth Welty Thompson and Mary Alice Welty White; Frank Hall Fraysur, letters to Eudora Welty, January 29, 1937, November 3, 1937, December 28, 1937.

4 Welty to Lyell, February 16, 1935, cited by permission of Elizabeth Welty Thompson and Mary Alice Welty White.

5 Toni Morrison, interview with Mel Watkins, *New York Times Book Review*, September 11, 1977, 48-50; Eudora Welty, "Powerhouse," in *A Curtain of Green* (New York: Doubleday, 1941), 257, and Welty, *One Writer's Beginnings*, 101; Eudora Welty, "Is Phoenix Jackson's Grandson Really Dead?" in *The Eye of the Story* (New York: Random House, 1979), 161.

6 Samuel Robbins, letter to Welty, July 18, 1936, Welty Collection, Mississippi Department of Archives and History, Jackson, Miss.; Eudora Welty, "Death of a Traveling Salesman," in *A Curtain of Green*, 244.

7 Eudora Welty, "A Word on the Photographs," in *Twenty Photographs* (Winston-Salem: Palaemon Press, 1980), n.p.

8 Gerard Manly Hopkins, "Pied Beauty," in *Poetry of the Victorian Period*, Jerome H. Buckley and George B. Woods, eds. (Glenview, Ill.: Scott, Foresman, 1965), 785; Harriet Pollack, "Photographic Convention and Story Composition: Eudora Welty's Uses of Detail, Plot, Genre and Expectation from 'A Worn Path' through *The Bride of the Innisfallen*," *South Central Review* 14.2 (1997): 26; Welty, et al., *One Time, One Place*, 3-4; Eudora Welty, *More Conversations with Eudora Welty*, Peggy Whitman Prenshaw, ed. (Jackson: University Press of Mississippi, 1996), 194-95.

9 Welty, *More Conversations with Eudora Welty*, 151; Eudora Welty, "Flowers for Marjorie," in *A Curtain of Green*, 194.

10 David M. Kennedy, *Freedom from Fear: The American People in Depression and War*, 1929-1945 (New York: Oxford University Press, 1999), 189; Welty, "Flowers for Marjorie," 189.

11 Welty, "Flowers for Marjorie," 193.

12 Welty, "The Whistle," in *A Curtain of Green*, 108.

13 Welty, et al., *One Time, One Place*, 8.

Brief parts of this essay have appeared in somewhat different forms and contexts in my book *The Welty Collection* (Jackson: University Press of Mississippi, 1988), 87, and in an essay I coauthored with Harriet Pollack, "Seeing Welty's Political Vision in her Photographs," in *Eudora Welty and Politics: Did the Writer Crusade?* Pollack and Marrs, eds. (Baton Rouge: Louisiana State University Press, 2001), 248, 250.

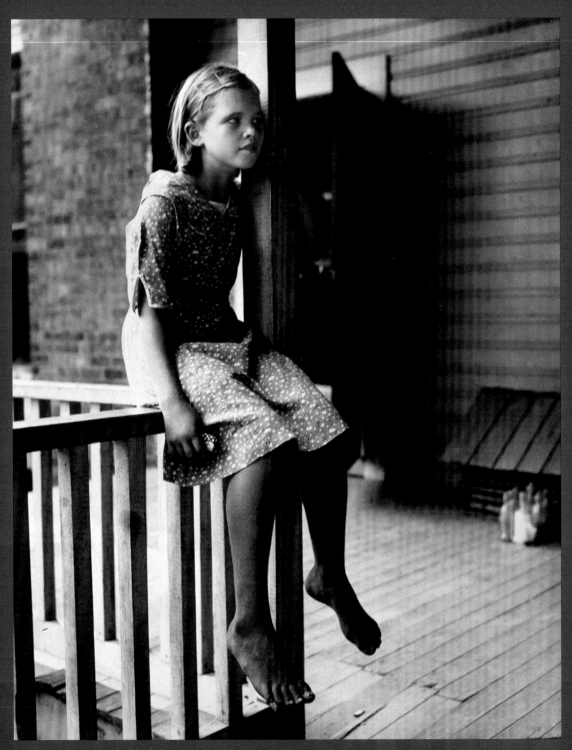

Eudora Welty, *Child on the porch*, 1935-1936. Eudora Welty Collection—Mississippi Department of Archives and History.

Back Home in Jackson

BY PATTI CARR BLACK

THERE MAY COME TO BE NEW PLACES IN OUR LIVES THAT ARE SECOND SPIRITUAL HOMES— CLOSER TO US IN SOME WAYS, PERHAPS, THAN OUR ORIGINAL HOMES. BUT THE HOME TIE IS THE BLOOD TIE. AND HAD IT MEANT NOTHING TO US, ANY OTHER PLACE THEREAFTER WOULD HAVE MEANT LESS, AND WE WOULD CARRY NO COMPASS INSIDE OURSELVES TO FIND HOME, EVER, ANYWHERE AT ALL. WE WOULD NOT EVEN GUESS WHAT WE HAD MISSED.¹

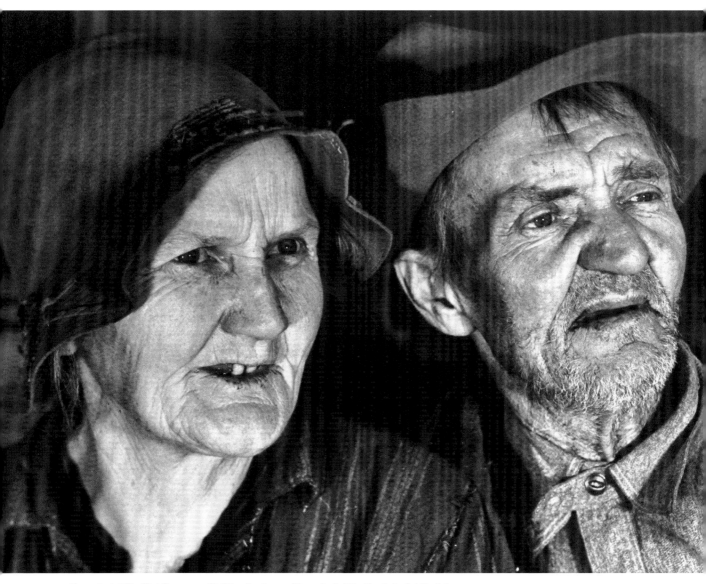

Margaret Bourke-White, *Elderly Sharecropper and his Wife*, no date. Courtesy of Margaret Bourke-White/Timepix, New York, New York.

WELTY AS PHOTOGRAPHER

When Welty came back to Jackson in 1931 because of her father's illness, she did not intend to stay the rest of her life. New York was her lodestar. Cities in general, with their cultural offerings, attracted her. At the University of Wisconsin, from which she graduated in 1929, she was known for going to Chicago as many weekends as she could manage. Her years at Columbia University in New York, 1930-1931, were filled with theater, art, music, and the excitement of being in a vibrant city. When she returned to Jackson and remained because of her father's death, she kept up with what was happening in the art world of New York, and she began to pursue seriously both photography and writing.[2]

The photography scene for women was enhanced when Margaret Bourke-White became America's first woman photojournalist. She was hired as a photographer for *Fortune* magazine in 1929 and moved to *Life* magazine when it was created in 1935. Welty's interest in photography was no doubt heightened by Bourke-White's work, but it was the work of another woman photographer that prompted Welty to begin seriously taking photographs of black culture. In a letter to Berenice Abbott in 1934 Welty wrote, "I have photographed everything within reason or unreason around here [Jackson], having lately made particular studies of negroes, with an idea of making a book, since I do not like Doris Ulman's [*sic*] pictures."[3] Doris Ulmann's romanticized, staged photographs of African Americans had been published the year before. The book, titled *Roll, Jordan, Roll*, was a study of the Gullahs of South Carolina, with text by Julia Peterkin.[4]

Welty had written to Berenice Abbott to inquire about the possibility of taking her class in photography at the New School for Social Research in Manhattan. It seems clear that she was seriously considering a career in photography. She wrote:

I can get no further here, because I know next to nothing about making my own prints, the chemistry involved, enlarging, etc. Will my 616 camera (6.3 lens and a common shutter) be all right to come to the school with? And would you make any attempt to provide entrée into the business world of photography for me if I were apt enough in absorbing your course? I am 25 years old, a graduate (1929) of University of Wisconsin, and studied advertising in the Business School at Columbia one winter. I have had lessons in painting and know something of certain principles in photography, therefore. Please communicate, telling me whether you think I am qualified for your course and would be better able afterward to make some large efforts and a little money in photography.

Welty pursued her photography career aggressively. In 1935 she submitted for publication a book of photographs called "Black Saturday," which was rejected by Smith and Haas in New York. In the spring of 1936 she landed an exhibition of her photographs in New York at Lugene Opticians' Photographic Galleries. That summer she applied, unsuccessfully, for a job as photographer with the Resettlement Administration, a program of President Franklin Roosevelt's New Deal.

Although her literary career was taking off with the publication of her first story, "Death of a Traveling Salesman," in 1936, she continued to spend a great deal of energy on photography during the next three years. In March 1937 she was given a second exhibition in New York at The Camera House. She submitted photographs to *Life* magazine and attempted to interest various publishers in her photographs combined with a collection of her stories. By 1939 she had had seven images published in *Life*, but three book publishers turned down her book of photographs, one because of the high cost of publishing photographs and the others, perhaps, because similar books were already in the field.[5]

Four years after Doris Ulmann's *Roll, Jordan, Roll*, Margaret Bourke-White published a book of photographs of the South, including images in Mississippi, titled *You Have Seen Their Faces* (1937), with text by Erskine Caldwell.[6] Although Welty surely admired Bourke-White's international work, the style and methods of the southern photographs could not have

been to her liking. Erskine Caldwell, Bourke-White's collaborator on the project (and later her husband), described Bourke-White's techniques:

She was in charge of everything, manipulating people and telling them where to sit and where to look and what not. She was very adept at being able to direct people. She was almost like a motion picture director.[7]

Welty's *modus operandi* was entirely different, growing out of her sensitivity to the inner complexities of other people. Bourke-White wrote of her experience in a black church:

We decided to slip lightly equipped into the Holiness church after the sermon was started, Mr. Caldwell with his pockets full of bulbs, and I with Ikonta and synchronizer attached. I believe the only reason we were successful was because the minister had never had such a situation to meet before. Photographers walking into the middle of a sermon and shooting off flash bulbs were something he had never had to contend with.[8]

Welty, working at the same time in Mississippi, wrote of her church photography:

I asked for and received permission to attend the Holiness Church and take pictures during the service; they seated me on the front row of the congregation and forgot me.... The pictures of the Bird Pageant were made at the invitation, and under the direction, of its originator, Maude Thompson; I would not have dared to interfere with the poses, and my regret is that I could not, without worse interfering with what was beautiful and original, have taken pictures during the Pageant itself.[9]

Welty always referred to her photographs as "snapshots." This term was not a self-effacing assessment. It was, instead, a statement of high intention. She valued the unpredictability of the moment. Concerning her photographs she said, "They were taken spontaneously—to catch something as I came upon it, something that spoke of the life going on around me. A snapshot's now or never." She was both fascinated by and committed to her method:

The human face and the human body are eloquent in themselves, and stubborn and wayward, and a snapshot is a moment's glimpse (as a story may be a long look, a growing contemplation) into what never stops moving, never ceases to express for itself something of our common feeling. Every feeling waits upon its gesture. Then when it does come, how unpredictable it turns out to be, after all.[10]

Bourke-White's photographs of African Americans were made to illuminate social problems; indeed, her preface states that "names and places have been changed to avoid unnecessary individualization, for it is not the author's intention to criticize any individuals who are part of the system depicted." Ulmann's photographs were a romanticized sociological study of a culture that "still lingered in the nimbus of charm that made life of the old South glamorous." Welty, whose writing and entire life focused on the individual, approached her photography of African Americans in the same way she wrote:

I was too busy imagining myself into their lives to be open to any generalities. I wished no more to indict anybody, to prove or disprove anything by my pictures, than I would have wished to do harm to the people in them, or have expected any harm from them to come to me.[11]

Of the three women photographers making a name for themselves during the early thirties, Welty seems to have the closest affinity for Berenice Abbott. Although Welty's photographs of African Americans seem to be antithetical to those of Ulmann's and Bourke-White's, Welty's New York scenes, taken at the same time as Abbott's, are quite similar to those that Abbott took as a Works Progress Administration (WPA) photographer. After frequent small exhibitions in New York starting in 1932, Berenice Abbott made a national reputation with those photographs in 1937 at an exhibition at the Museum of the City of New York titled *Changing New York*. The museum published a book of the photographs in 1939, well after Welty had taken her similar New York City photographs in 1935.[12]

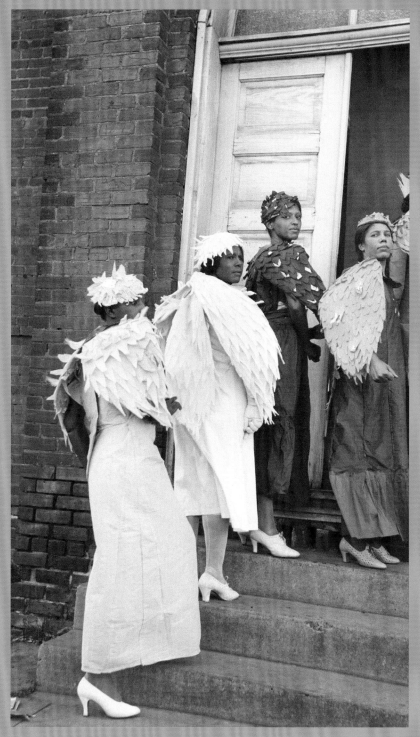

Eudora Welty, *Pageant of birds, Farish Street Baptist Church, Jackson*, prior to 1935. Eudora Welty Collection – Mississippi Department of Archives and History.

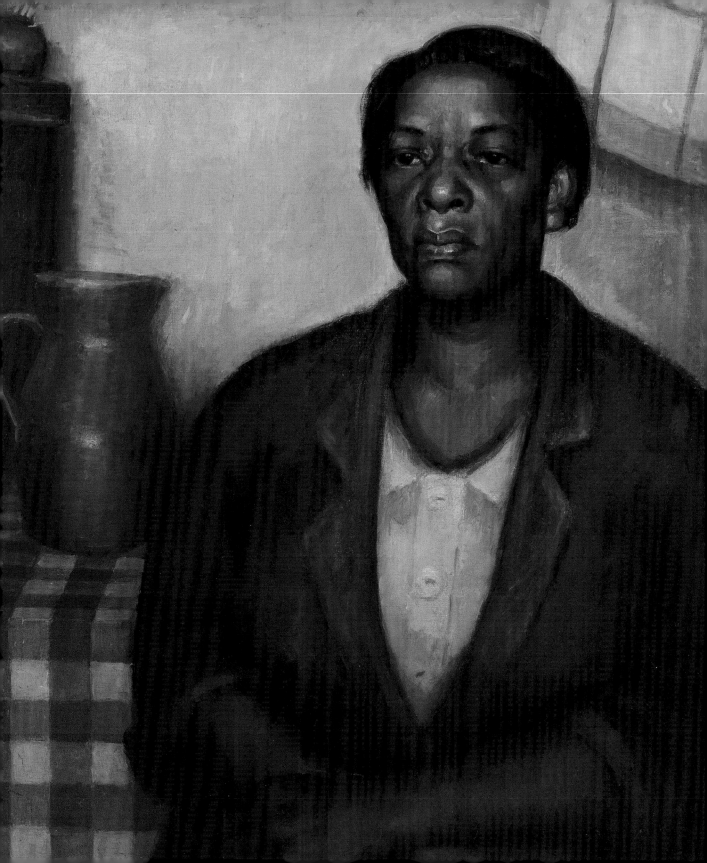

Welty continued to take photographs after 1939, but not with the frequency, intensity of purpose, and energy that she expended through 1939. With mounting literary success and her stories selected for publication in *Best Short Stories* of 1938 and 1939 and *O. Henry Prize Stories* of 1939, Welty turned her major attention to writing, but her photographs of the Depression stand with the best of American work of that period.

WELTY AND JACKSON'S ART SCENE

At the age of one, Eudora probably was among the strolling spectators who watched an Italian sculptor at work in the window of Kennington's Department Store on Capitol Street.[13] There is no record of this precocious viewing, but we know that her parents conscientiously exposed her to books, pictures, and cultural experiences throughout her childhood, and that her family lived only a few blocks from Capitol Street.

The sculptor in the window with his maul and block of marble represented the lively interest in art that began to blossom in Jackson at the turn of the century and continued throughout Welty's lifetime. When she came home to Jackson in 1931, she returned to the familiarity of Jackson's small community of artists. Bessie Cary Lemly, then in her sixties, taught in the Belhaven College Art Department just across the street from the Welty's new house. Dozens of others in town—her mother's friends as well as her own—were occasional artists. Marie Atkinson Hull, a neighbor in the Belhaven neighborhood, was the acknowledged star of the local art scene. She had studied at the Art Students League of New York and in Europe. Just before the economic crash of 1929, she had won a prestigious prize that allowed her to paint in Europe for two months. Welty, attending Columbia University in New York, had missed the exhibition of Hull's European work that the Mississippi Art Association gave in 1930.

Soon Jackson would have a trio of younger artists with equally serious intentions. All three were graduates of The Art Institute of Chicago, and all were in their home state of Mississippi to ride out the Great Depression. Karl Wolfe, Helen Jay Lotterhos, and William Hollingsworth arrived back in Jackson shortly after Eudora's return in 1931, and they all became friends and mutual admirers.

William Hollingsworth, sketches of artist, probably Marie Hull, no date. graphite on paper. Courtesy of Mississippi Museum of Art, Jackson.

Marie Hull, *Melissa*, 1930. oil on canvas. Collection of Mississippi Museum of Art, Jackson. Purchase. 1972.006.

These young artists were living in a nation, a state, and a city characterized by nationalism, both artistic and political. World War I had produced a great need for a national sense of identity. The Depression, with the collapse of industry and business, deepened America's need to look at and define the national character. American artists nationwide focused on the activities and patterns of everyday life in America, some to critique it, some to glorify it, and others simply to show it. This focus, collectively called the American scene movement, virtually produced an American self-portrait. Some of the artists were social realists—William Gropper, Ben Shahn, Jack Levine, Philip Evergood—whose works illuminated urban societal problems. Others were Regionalists, the dominant group, intent on creating an authentic American art through the experiences of rural America. The lead artists of this group were Thomas Hart Benton, Grant Wood, John Steuart Curry, and Charles Burchfield.

Welty and Welty's artist friends in Jackson focused on the American scene, but none of them were on the hyperpatriotic, almost jingoistic, bandwagon that the American scene movement evoked in many of the nationally known artists. Nor was Welty aligned with the artists concerned with social reform or the Farm Security Administration photographers assigned to document poverty in the South. Just as Welty never considered herself to be a part of the Agrarians, a southern literary group, she was never philosophically a part of the various art movements of the era. She shared the zeitgeist of the times in the motivation for her work, "to see the nature of the place I'd been born into," but her approach always focused on the individual.

By 1933 President Roosevelt had included in his economic recovery program called the New Deal, several programs for artists. Almost all of Mississippi's leading artists—Marie Hull, Karl Wolfe, John McCrady, Walter Anderson—were employed at some time by the Federal Art Project. Welty herself worked for the Works Progress Administration as a junior publicist, writing feature stories and conducting interviews. Her job required her to travel around the state, and she took advantage

Helen Jay Lotterhos, *Girl with Mandolin* [Eudora Welty], 1944. charcoal on paper. Collection of Family of Helen Jay Lotterhos, Jackson, Mississippi.

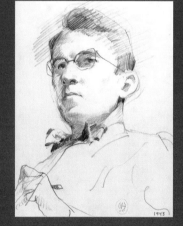

Eudora Welty, sketch of Helen Jay Lotterhos, no date. watercolor on paper. Collection of Estate of Eudora Welty, Jackson, Mississippi.

Helen Jay Lotterhos, sketch of artist, probably Karl Wolfe, 1954. watercolor on paper. Collection of Family of Helen Jay Lotterhos, Jackson, Mississippi.

William Hollingsworth, *Self-Portrait*, 1943. graphite on paper. Collection of Mississippi Museum of Art, Jackson. Bequest of Jane Oakley Hollingsworth. 1987.050.

of these travels to take her own photographs. Of that time and place, Welty wrote:

I loved that job. I traveled the entire state of Mississippi taking pictures. I saw so many people who had nothing. You can't imagine what it was like, the levels of poverty. But even as people struggled, I was aware at a deep level of the richness of life going on all around me. I felt something about this time so strongly that the images stayed with me always.[14]

All three of the young Jackson artists—Lotterhos, Hollingsworth, and Wolfe—struggled to be professional artists, honing their techniques and practicing their craft. All three were interested in figurative work and landscapes. The tradition of realism, with only slight echoes of their training in European modernism, dominated their works. They were all active in the Mississippi Art Association, presenting their shows and the work of others at the Jackson Municipal Art Gallery. Their lives were entwined with each other and with Welty as she embraced their talents and efforts.

Helen Jay Lotterhos (1905-1981) returned home to Jackson from The Art Institute of Chicago in 1931, the same year that Eudora returned from her year at Columbia University. They became good friends, sharing a lively interest in art and writing.[15]

Lotterhos grew up in McComb and moved to Jackson when she was fourteen. She graduated from Central High School at Jackson in 1923, two years before Eudora. She received her bachelor's degree from Millsaps College in 1927. Since Millsaps did not have an art department at that time, Lotterhos studied art for a year under the tutelage of her cousin, Marie Hull, in preparation for The Art Institute of Chicago. In the fall of 1928 she entered The Art Institute of Chicago and studied there for a year. She returned home in the fall of 1929 and set up a studio and classroom at 714 Fortification Street in Jackson. She went back to Chicago in September 1930 and studied there until July 31, 1931, when she returned to Jackson.

As her friendship with Welty developed, they often went on

sketching trips around Jackson. Lotterhos wrote of one such occasion "in early November" when Eudora took her to see an abandoned house that had caught her imagination: "We set out right after lunch in the warmth of sun and tang of air of this season in Mississippi, fortified for the afternoon with sweaters and trustworthy tweeds, apples and chocolate bars, camera and sketching paraphernalia."[16] After "ten miles of pavement, two of dirt," they left the car at the side of the road and made a pathway through brambles and vines, over barbed wire, through abandoned cornfields, and finally through the remnants of an orchard, to an old brick house, which both painted in watercolors. A photograph by Welty of "the old pink house" was published in *Vogue* magazine in 1944.[17]

Lotterhos continued to be an active artist and teacher in Jackson throughout her lifetime. She exhibited extensively in the exhibitions sponsored by the Mississippi Art Association, Mississippi Federation of Women's Clubs, Mississippi State Fair, and the Southern States Art League. She had shows at the High Museum of Art in Atlanta, the Delgado Museum of Art in New Orleans, Belhaven College in Jackson, and Rockefeller Center in New York City. Karl Wolfe wrote in the *Jackson Daily News*, October 25, 1934:

In her watercolors Miss Lotterhos is even more herself. She paints with an easy breadth, in a clear, liquid medium, and manages somehow to put individuality into each stroke. Her choice of color is not only exquisite, but adds a fillip of surprise and delight to each of these paintings.

During her lifetime Lotterhos had several poems published in the *Christian Science Monitor*. She died in 1981 at Jackson.

William Hollingsworth (1910-1944)[18] was a native Jacksonian. He and Welty knew each other as children. They were born a block apart, grew up in the same neighborhood, and attended the same public schools. Like Welty, Hollingsworth's earliest interest in visual arts was drawing cartoons, and like Welty, who drew cartoons for publications at Mississippi University for Women, he contributed cartoons to his college annual at The University of Mississippi. Enrolled in The Art Institute of Chicago, 1930-1934, he gave up cartoons for serious art.

Left to right: Eudora Welty, Dolly Wells, Laura Middleton, Helen Jay Lotterhos, Ann Wright, and kneeling, Seta Alexander. Courtesy of Family of Helen Jay Lotterhos, Jackson, Mississippi.

While at the institute he married a fashion artist from Illinois, Jane Oakley, and had a son. They intended to stay in Chicago, but the Depression forced him in 1934 to bring his family to Jackson, where they lived with his father. Hollingsworth found employment at the Federal Emergency Relief Administration (FERA) office in the Standard Life Building, where Welty's WPA office was located. With a wife and baby to support, and an ailing father to care for, his government job had to take precedence over his art. When the FERA office closed down in 1938, Hollingsworth set up a studio in his father's house on North President Street and devoted himself full time to painting. In 1941 he established the art department at Millsaps College and taught there until 1943. He and Karl Wolfe, the only other man in Jackson attempting to be a professional artist, became friends.

Hollingsworth found immediate success with his art. In his first year back in Jackson, an exhibition was held at the Jackson Municipal Art Gallery featuring Hollingsworth's paintings along with the photographs of Welty and Hubert Creekmore, another Welty friend in Jackson. That same year, 1934, he won the gold medal from the Mississippi Art Association for *Tired, Oh, Lord, Tired*, and had *Black and White* accepted in exhibitions at the Cincinnati Art Museum and The Art Institute of Chicago. Hollingsworth's work steadily garnered attention in exhibitions at New York, Atlanta, Memphis, Jackson, and New Orleans. In 1941 Welty and Hollingsworth collaborated on a show of work by Welty's friend Karnig Nalbandian, whom she had met at Yaddo in 1940. At the beginning of World War II in 1942 he enlisted in the U.S. Navy, but was discharged within two weeks because of bad eyesight. Despondent over the war and his father's bad health, he nevertheless remained passionate about his work and continued to record scenes in and around Jackson. He made excursions into the countryside to paint landscapes by natural light. Karl Wolfe sometimes accompanied him on trips to the Pearl River and along Old Canton Road. Occasionally they would see Lotterhos and Welty at work in the same locales.

In the summer of 1944 Hollingsworth took his own life. Two of his watercolors, prized by Eudora Welty, hung in the Welty house on Pinehurst Street.

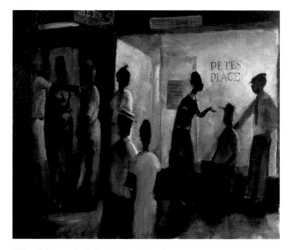

William Hollingsworth, *Black and White*, no date. oil on canvas. Collection of Mississippi Museum of Art, Jackson. Gift of Mrs. William Hollingsworth. 1944.001.

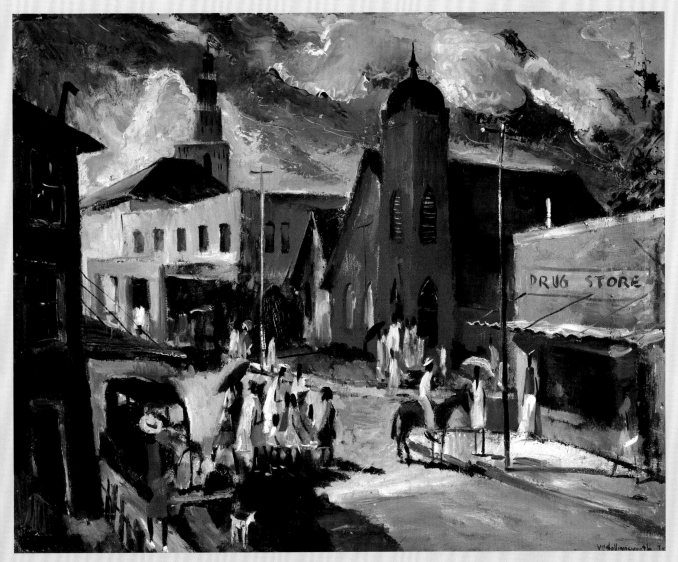

William Hollingsworth, *High Farish*, 1941. oil on canvas. Collection of BancorpSouth, Jackson, Mississippi.

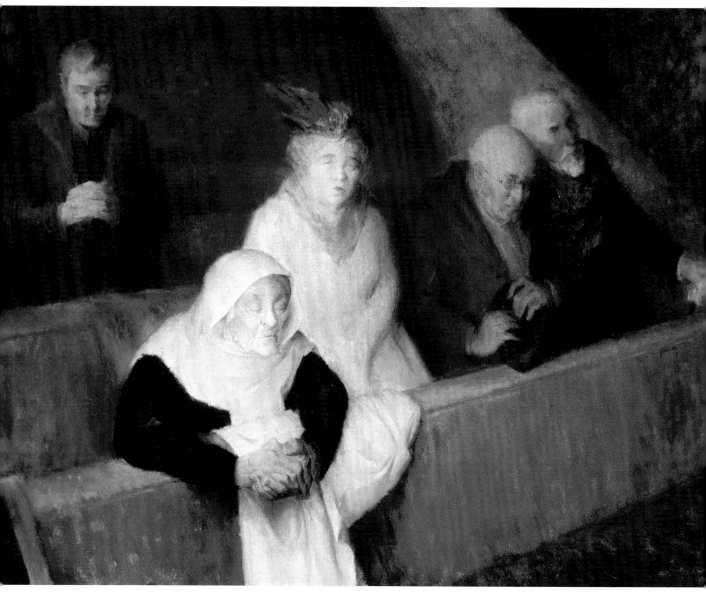

Karl Wolfe, *People in Church*, circa 1936. oil on board. Collection of Mississippi Museum of Art, Jackson. Gift of Mildred Nungester Wolfe. 1989.097.

Only one of the three young artists working in Jackson was new to Eudora. In 1931, the year she returned from Columbia University, a young artist named Karl Wolfe (1904-1985) moved from Columbia, Miss., to Jackson.[19] Wolfe must have been a welcome figure to Eudora, who had reluctantly given up the riches of the New York art world to return home. He had studied at The Art Institute of Chicago from 1924 to 1928, traveled in Europe on an art scholarship, and returned home to ride out the Great Depression. After the surprise of good sales at an exhibition sponsored by the Mississippi Art Association in 1931, he moved from Columbia to Jackson to pursue his career. He set up a studio at 828 North Congress Street.

He began garnering prizes early in his career, from the Mississippi Art Association, the Alabama Art League, and the Southern States Art League. An early scene painting, *Dinner on the Grounds*, took first prize in figurative painting at the 1934 Southern States Art Show in Memphis. For an enthusiastic market in Mississippi, he painted floral still lifes and later began pursuing portrait commissions. He once estimated that he painted over eight hundred portraits in his lifetime. He spent summers studying at the summer camp of the Pennsylvania Academy of the Fine Arts and at the Dixie Art Colony in Alabama, where he met artist Mildred Nungester, whom he later married.

Wolfe became friends with William Hollingsworth as soon as Hollingsworth arrived back in Jackson in 1934. They often talked together about art and its relationship to their lives, they sometimes went on sketching trips, and they both worked long hours at the Municipal Art Gallery, making it a viable venue for professional artists. Wolfe was as passionate about his work as Hollingsworth and although he became primarily a portrait painter to support his family, he considered portraiture a deep artistic challenge. Wolfe joined the army in 1943 and was stationed at Colorado when Hollingsworth committed suicide in 1944.

Karl Wolfe brought his new wife, Mildred, to Jackson shortly after the war ended in 1945, and they both had a full lifetime of making art, working in oils, watercolors, ceramics, and stained glass. The Wolfe Studio is an important art landmark in Jackson, still providing work and exhibit space for his wife and their daughter, Bebe Wolfe.

Mildred Wolfe, *Portrait of Karl*, circa 1975. oil on canvas. Collection of Mildred Nungester Wolfe, Jackson, Mississippi.

Marie Atkinson Hull (1890-1980)[20] had an influence on the lives of all four of the young artists in Jackson during the Depression years. She was charismatic, passionate, informed, energetic, and peripatetic. She taught painting to both Eudora Welty and Helen Jay Lotterhos, her cousin, and was an art colleague of Karl Wolfe and William Hollingsworth. She invited Walter Anderson of Ocean Springs to spend weekends in her home when he was hospitalized at the Mississippi State Hospital in Whitfield, and she championed him in competitions for federal projects. She was for over a half century the dynamo that turned the wheels of art in Mississippi. She was born in Summit and moved to Jackson to study music at Belhaven College. She took her first art lesson in 1910, after graduating from college, from Aileen Shannon Phillips in Jackson. She married architect Emmett J. Hull in 1917 and lived in Jackson the rest of her life. She studied at the Pennsylvania Academy of the Fine Arts from 1911 to 1912 and the Art Students League of New York in 1922. She traveled extensively throughout her career, painting in Europe, Canada, Mexico, and all around the United States. She exhibited widely: of her twenty-seven solo shows, only eleven were in the South. She won many medals and first-prize ribbons during her painting career of almost seventy years, and she was a friend and mentor to artists all over the state.

Other important artists were at work in Mississippi, recording the varied landscapes and town scenes from the Gulf Coast to the hills of Oxford. Their interests were as diverse as the landscape: city scenes, pastoral countryside, and the impact of history and religion.

John McCrady (1911-1968) was considered early in his career to be one of the leading southern painters of the American scene movement.[21] The powerful components of his work—history, religion, and black culture—were all part of his background. Born in Canton, the son of an Episcopal minister, he moved as an infant to the cotton town of Greenwood, then to Hammond, La., and as a teenager to Oxford when his father was named dean of philosophy at The University of Mississippi. After spending two college years there, he enrolled at the New Orleans Art School in 1932. At the end of a year he was awarded one of the ten national

1934 scholarships to the Art Students League of New York. After a year in New York he settled in New Orleans and began painting the religious and rural paintings that brought him national attention. Like most young artists of his day he was employed by the Federal Art Project (*Oxford on the Hill* was his final work for the agency). The years before World War II were filled with prestigious exhibitions at the Whitney Museum of American Art, the Saint Louis Art Museum, the Corcoran Gallery of Art in Washington, and the Delgado Museum of Art in New Orleans.

It is not known whether Welty and McCrady knew each other, but certainly they knew of each other's work; both were spotlighted in national magazines in 1937. That year, McCrady had his first one-man show in Philadelphia. Covering that exhibition, *Time* magazine called McCrady "a star risen from the bayous" whose work would do for southern art what Faulkner's was doing for southern literature. That same year Welty had two short stories published in the *Southern Review* and *Prairie Schooner* and six photographs in the November 8 issue of *Life* magazine.

During the war McCrady worked as a tool designer and poster artist to aid the war effort, and in 1942 he and his wife opened the John McCrady Art School in New Orleans. After the war Abstract Expressionism and a shift toward international concerns eclipsed his work outside the South.

Walter Anderson (1903-1965),[22] who is now known as one of the South's greatest artists, spent most of his artistic energies during the Depression designing and painting ceramic pieces to support himself and his wife, Agnes Grinstead, whom he married in 1933. He worked at Shearwater Pottery, founded by his brother Peter Anderson. From 1937 to 1940 Anderson was in and out of mental institutions, struggling to regain his life.

Although Welty may have been acquainted with the Anderson brothers' ceramics, she became aware of Walter Anderson as an artist through his mural project created for the Ocean Springs High School under the WPA. She was also aware of the support that Anderson received in Jackson to paint the federal building mural. The commission was awarded to an artist who had never been to Mississippi over the protestations of

Walter Anderson, *Black Skimmer*, circa 1930. oil on board. Collection of Family of Walter Anderson, Ocean Springs, Mississippi.

John McCrady, *Oxford on the Hill*, 1939. oil on canvas. Collection of City of Oxford, Mississippi.

Dusti Bongé, *Where the Shrimp Pickers Live*, 1940. oil on canvas.
Collection of Mississippi Museum of Art, Jackson. Gift of Dusti
Bongé Foundation, Inc. 1999.012.

the local committee headed by Emmett J. Hull (Marie Hull's husband).

Welty never met Anderson, but she had a closer awareness of him in 1939 when he spent weekends on leave from the state hospital at Whitfield with Marie Hull. When he was discharged, his mother rented a small cottage near the Jackson zoo to keep her son close to the hospital. Some of Anderson's sketches of zoo animals and birds date from this period. At the end of that year, Anderson left his mother and walked two hundred miles home to begin working at his art again. In 1940 he and his wife and children moved to Gautier, where he had six productive and relatively peaceful years at his father-in-law's house. Back at his home in Ocean Springs, and appropriating Horn Island as his world, he was to produce an astonishing body of work before his death. Horn Island was the American scene that truly engaged him, although he painted some fascinating watercolors in the town of his birth, New Orleans, watercolor and pen sketches of his family life in Ocean Springs, and murals depicting activities on Biloxi beach. During his lifetime he sculpted in wood, carved pieces of furniture, created ceramic figures, carved and decorated earthenware, cut large linoleum blocks for printing, designed textiles, painted with oils, and created murals. But above all, he left thousands of vibrant watercolors done on Horn Island which are, according to critic John Russell, "among the best American watercolors of their date." [23]

The Gulf Coast was also the home of Dusti Swetman Bongé (1903-1993) of Biloxi,[24] one of the few southern artists whose art was solidly in the modernist school. She pursued a stage career in New York after graduating from Blue Mountain College in Mississippi and the Bush Conservatory in Chicago. After her marriage to Archie Bongé, an artist whom she met in Chicago, the couple and their young son moved back to her hometown of Biloxi in 1934. At the death of her husband two years later, Dusti Bongé immersed herself in art, which had long been an interest of hers. She began to record Biloxi scenes in oil and watercolor, sketches of the camps where shrimp pickers lived. She had her first one-person show in New York in 1939 at the Contemporary Arts Gallery and began regularly showing at Betty Parsons Gallery in New York City

in the 1940s. She continued to work in Biloxi until her death at the age of ninety in 1993.

Caroline Russell Compton (1907-1987) of Vicksburg began her painting career after graduating from Sweet Briar College in Virginia and attending New York's Grand Central School of Art from 1927 to 1929. Much of her work, in oils and watercolors, quietly celebrates her hometown and provides views of Vicksburg's streets and structures.

Leon Koury (1909-1993) of Greenville sculpted in bronze. During the Depression he also worked as director of the WPA Mississippi Art Project. The human figure was his major interest, and during the early years in Greenville he began a series of black figures, which included *The Compress Worker* (1941), now in the collections of Memphis Brooks Museum of Art. Koury lived in the North for a number of years and returned to Greenville in 1961, where he remained until his death.[25]

Another sculptor from Mississippi became an acclaimed expatriate artist producing a series of busts and figures of African Americans. Richmond Barthé (1901-1989)[26] was born in Bay St. Louis and began his work as a painter. With the financial aid of a Catholic priest, Barthé attended The Art Institute of Chicago during the same years that Karl Wolfe was there. At the institute Barthé became fascinated with clay modeling, and for the rest of his successful career worked in bronze. Most of his professional life was spent in Jamaica and Europe. He is represented in the nation's major collections: The Metropolitan Museum of Art, the Whitney Museum of American Art, the Smithsonian Institution, the Pennsylvania Academy of the Fine Arts, and the Virginia Museum of Fine Arts. He was honored by President Carter in 1980. Several Mississippi institutions have his work. *The Stevedore* is in the collections of the Lauren Rogers Museum of Art, Laurel; *The Awakening of Africa* and *The Negro Looks Ahead* are in the collections of The University of Southern Mississippi, Hattiesburg.

Caroline Compton, *South on Monroe*, no date. oil on board. Collection of Mississippi Museum of Art, Jackson. Bequest of the artist. 1987.124.

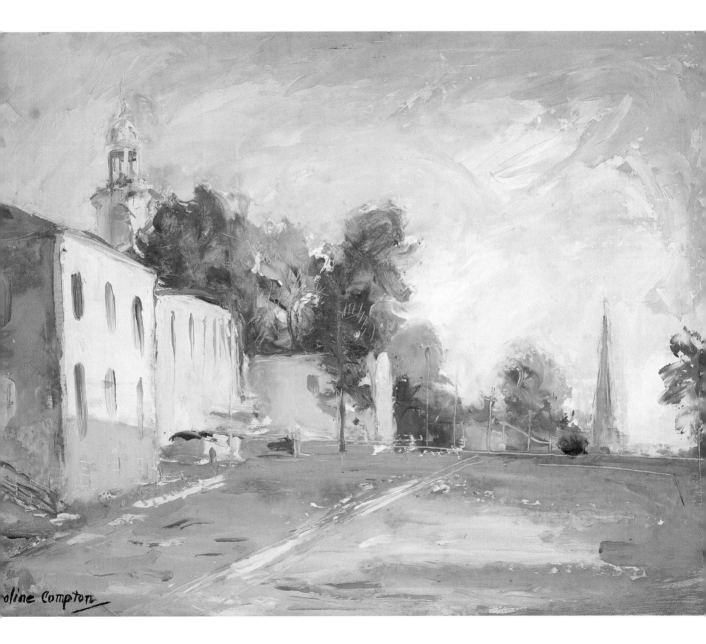

oline Compton

Richmond Barthé, *Feral Benga*, 1937. bronze. Collection of Mississippi Museum of Art, Jackson. Purchase, with funds from McCarty Fund and McCravey Fund. 2002.016.

POSTLOGUE

Back in Jackson Eudora Welty, after riding out the Depression, made the decision to stay at home. In subsequent years she frequently traveled for pleasure and to give lectures and readings, and she worked at the *New York Times* in the summer of 1944, but she always returned to the place where she was born. The accretions of memory, which she called "the treasure most dearly regarded by me," fed her stories, characters, landscapes, and dialogue. She lived in Jackson the rest of her life, writing with quiet power and eloquence, stories, novels, essays, and book reviews. In her writing, photography, and personal life, she fulfilled her continuing wish "to part a curtain, that invisible shadow that falls between people, the veil of indifference to each other's presence, each other's wonder, each other's human plight." Her literary career spanned eight decades and brought her virtually every honor possible in the literary world of America.

NOTES

1 Eudora Welty, "Place in Fiction," in *The Eye of the Story* (New York: Random House, 1978), 131.

2 Informal conversations between the author and Eudora Welty from 1958 to 2001.

3 Eudora Welty to Berenice Abbott, August 9, 1934. Quoted with permission of the Estate of Eudora Welty.

4 Julia Peterkin and Doris Ulmann, *Roll, Jordan, Roll* (New York: Robert O. Ballou, 1933). Peterkin's *Scarlet Sister Mary* won the Pulitzer Prize for literature in 1929.

5 See Suzanne Marrs, *The Welty Collection: A Guide to the Eudora Welty Manuscripts and Documents at the Mississippi Department of Archives and History* (Jackson: University Press of Mississippi, 1988) and Noel Polk, *Eudora Welty: A Bibliography of Her Work* (Jackson: University Press of Mississippi, 1994).

6 Erskine Caldwell and Margaret Bourke-White, *You Have Seen Their Faces* (New York: Modern Age Books, 1937).

7 Vicki Goldberg, *Margaret Bourke-White* (New York: Harper and Row, 1986).

8 Caldwell and Bourke-White, *You Have Seen Their Faces*, 53.

9 Eudora Welty, et al., *One Time, One Place* (New York: Random House, 1971), 5.

10 Ibid., 8.

11 Ibid., 6.

12 Berenice Abbott, *Changing New York* (New York: E. P. Dutton and Co., 1939).

13 *Jackson Daily News*, September 29, 1910, described Italian sculptor Fiori Giovani, who had been invited to Jackson "for the liberal education to Jackson citizens who had no prior knowledge of sculptors and their methods of work."

14 Eudora Welty interview with Marie Dawson, *Poets and Writers*, September/October 1997.

15 I am indebted to Margaret Lotterhos Smith of Houston for biographical information on her aunt.

16 Helen Jay Lotterhos, "The Old Pink House," typescript, 4 pp., n.d.

17 Eudora Welty, "Literature and the Lens," *Vogue*, August 1, 1944, 102-3.

18 See Jane Hollingsworth, ed., *Hollingsworth: The Man, the Artist, and His Work* (Jackson: University Press of Mississippi, 1989).

19 See Karl Wolfe, *Mississippi Artist: A Self Portrait* (Jackson: University Press of Mississippi, 1970).

20 See Mary D. Garrard, *Marie Hull, 1890-1980* (Cleveland: Delta State University, n.d.).

21 See Keith Marshall, *John McCrady: 1911-1968* (New Orleans: New Orleans Museum of Art, 1975).

22 See Agnes Grinstead Anderson, *Approaching the Magic Hour: Memories of Walter Anderson*, Patti Carr Black, ed. (Jackson: University Press of Mississippi, 1989).

23 John Russell, *New York Times*, February 14, 1985.

24 Patti Carr Black, *Art in Mississippi: 1720-1980* (Jackson: University Press of Mississippi, 1998), 238-39.

25 Ibid., 201-4.

26 Ibid., 204-5.

Framing Time in Expressive Spaces:

Eudora Welty's Stories, Photographs, and the Art of Mississippi in the 1930s

BY FRANCIS V. O'CONNOR

EVER SINCE I HAD BEGUN TAKING PAINTING LESSONS, I HAD MADE SMALL FRAMES WITH MY FINGERS, TO LOOK OUT AT EVERYTHING . . . ALL THROUGH THIS SUMMER I HAD LAIN ON THE SAND BESIDE THE SMALL LAKE, WITH MY HANDS SQUARED OVER MY EYES, FINGER TIPS TOUCHING, LOOKING OUT BY THIS DEVICE TO SEE EVERYTHING: WHICH APPEARED AS A KIND OF PROJECTION. IT DID NOT SEEM TO MATTER TO ME WHAT I LOOKED AT; FROM ANY OBSERVATION I WOULD CONCLUDE THAT A SECRET OF LIFE HAD BEEN NEARLY REVEALED TO ME — FOR I WAS OBSESSED WITH NOTIONS ABOUT CONCEALMENT, AND FROM THE SMALLEST GESTURE OF A STRANGER I WOULD WREST WHAT WAS TO ME A COMMUNICATION OR PRESENTATION.[1]

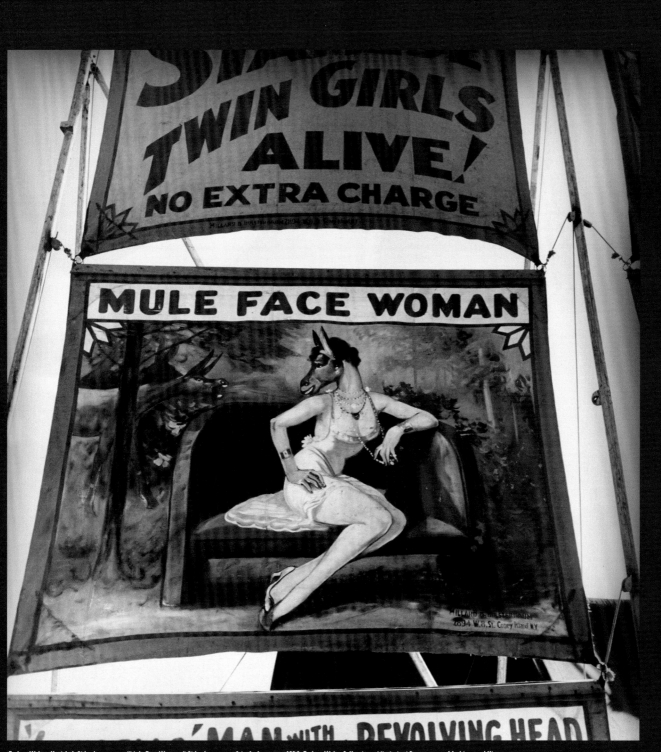

Eudora Welty, *Untitled. Side show poster "Mule Face Woman," Side show, state fair, Jackson,* post 1936. Eudora Welty Collection – Mississippi Department of Archives and History.

EUDORA WELTY'S STORIES OF THE 1930S

Mississippi in the 1930s, to judge from Eudora Welty's first book of stories,[2] was a dire place—a veritable paradise for a social realist—except that she does not overtly lament the Depression nor protest her characters' condition. Instead, using a variety of voices and devices, she makes the reader feel for them.

Thus, we come to care about, among others, a simple-minded girl being dragged off to an institution by batty housewives until an equally hapless prospective husband materializes to provide a more virtuous solution; a wife who finds a newspaper account of her husband shooting her to be a case of mistaken identity that nonetheless arouses his attention; a rapist hiding from the police by playing a petrified man in a freak show; an elderly African American man who once ate live chickens as a geek in a side show; a postmistress who flees her squabbling family to live in her post office; a distant couple who use their bedding and clothes to protect their crops during a frost and then come together to warm themselves by burning the kitchen table; a simple-minded woman who drowns herself amid the chaos of caring for a drunken brother, a comatose father, and a domineering older sister; an eccentric middle-aged man who keeps two weird households in the same town; a murder in New York of a pregnant woman by her hallucinating lover; a woman who gardens all the time and comes close to murdering her young black assistant; a campfire girl who brings a plant to a nursing home and gets involved with two senile old women; a hallucinating salesman who has a fatal heart attack after a bout with the flu; an old black woman who walks miles to get free throat syrup for a grandchild who had swallowed lye.[3]

At the exact center of this dire catalogue of hallucination, violence, and pathos, the ninth of the seventeen tales— "A Memory"—written in Welty's distinctive discursive voice, describes the author observing life through the frame of her fingers, looking for secrets. She finds just the right compositional correlatives—as if planning a painting or a photograph —to make us see each of her characters from the right angle at just the most revealing moment, while she crops out

everything else. She does not do this by means of detailed visual description, but through the perceptions of her curious characters deftly expressed in dialect and dialogue. Her verbal dexterity and psychological acumen are amazing for a woman in her twenties, although her taste for the macabre makes you wonder if her photographs are going to be a cross between the Surrealism of George Platt Lyons and the pathologizing of Diane Arbus. This suspicion is not completely unallayed by looking at the visual art produced in Mississippi during the period in which her photographs were taken and her stories written.

EUDORA WELTY AND THE NEW DEAL PROJECTS DURING THE 1930S

Welty liked to point out that the onset of the Great Depression was hardly noticeable in Mississippi—it being the poorest state in the nation.[4] If the most vulnerable individuals across the country were those involved in the arts, in Mississippi the only consolation was that there were fewer to suffer.

In 1934 twelve artists enrolled in the the first of the New Deal art programs, the Public Works of Art Project (PWAP). An official government report in 1935 indicated there were only seven "artists, sculptors or teachers of art" in Mississippi out of over eighty thousand on relief.[5] The WPA was active in the state by the fall of 1935, engaging many of those persons in practical public projects such as paving roads or installing sewers and drainage pipes.

Also at this time forty-two Mississippi visual artists were identified, of whom thirty were registered for relief.[6] There is evidence that the remaining artists were reluctant to endure the embarrassment of the relief process. This pride, plus suspicion of government programs, resulted in the WPA Federal Art Project (WPA/FAP) not being established as an effective program in Mississippi until 1939.[7] At that time administrative changes permitted the individual states more direct control over what had been a national program run from Washington since 1935.

In order to maintain support for its work relief activities, the WPA had a small public relations office operating from 1935 on. It consisted of a journalist, Louis Johnson, and later of

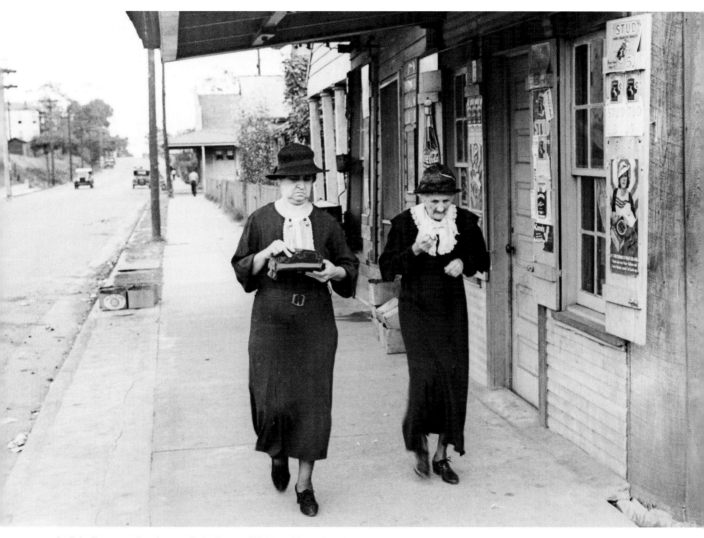

Ben Shahn, *Two women walking along street, Natchez, Mississippi*, 1935. Library of Congress, Prints & Photographs Division, FSA-OWI Collection, LC-USF33-006093-M4 DLC.

Thomas Hart Benton, *Going Home*, 1937. lithograph. Collection of Mississippi Museum of Art, Jackson. Bequest of Sara Virginia Jones. 1991.24.9. © T.H. and R.P. Testamentary Trusts/Licensed by VAGA, New York, New York.

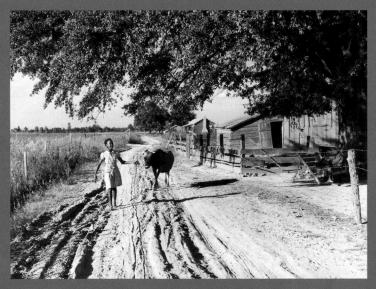

Marion Post Wolcott, *Daughter of Cube Walker, Negro tenant purchase client, Belzoni, Mississippi Delta, bringing home cow from the fields in the evening. Mississippi Delta, Mississippi*, 1939. Library of Congress, Prints & Photographs Division, FSA-OWI Collection, LC-USF34-052272-D DLC.

an assistant, Eudora Welty, who sometimes took photographs for her job, as well as for herself. They traveled the state and fed stories about the WPA's activities and achievements to the local press.[8] She thought of her work as "snapshots" and distinguished it from that of the government projects that supported photography—such as the WPA/FAP and the Farm Security Administration (FSA). This explains the wider range of subjects to be found in her photographs—and, as we shall see below, their difference from those produced under the other New Deal programs.

THE SITUATION OF ART IN AMERICA IN THE 1930S

Mississippi was a naturally conservative state, and the imagery its artists produced during the New Deal era reflects a local culture far more interested in exploring its version of the "American scene" than becoming overtly involved in social protest art, or the more radical modernist styles such as Cubism, Surrealism, Expressionism, and Abstraction. On the other hand, even the most conservative artists could not ignore the vital visual culture of the times. The latter filtered down to them through the big city and local art schools they attended, national art magazines and exhibitions, and the artistic controversies over modern art bruited in the press since the famous Armory Show of 1913.

Also during the 1930s, the creative activities of such nationally reported figures as the Mexican muralist Diego Rivera, the Missouri muralist Thomas Hart Benton, the Spanish surrealist Salvador Dalí, and, somewhat later, the New York abstractionist Stuart Davis and German expressionist Max Beckmann, challenged the art world and general public with their powerful personalities, outspoken views, and visually arresting works. America's artistic isolationism and conservatism slowly absorbed these new styles and forms rooted in European modernism.

The new way of seeing which these artists and their followers promoted was, first of all, strongly influenced by Cubism. Rooted in the achievements of Paul Cézanne, it provided modernism with a fundamental visual vocabulary. It was a conceptual art that went beyond what the eye could see to what the mind might know. Cubists sought to get down to the intrinsic structures and location of an object, not merely what

was optically perceptible. Since the mind could conceive at once the back, front, and two sides of an object, a radical style resulted, which permitted the simultaneous depiction of multiple viewpoints. Traditional artists, in contrast, had settled for acknowledging the immutability of persons and things while identifying them with symbols, signs, and allegories.

Surrealists tried to heighten our perception of reality by means of complex rearrangings of the ordinary. Just as Cubists tried to apply the new insights of Albert Einstein's relativity to the natural object in space and time viewed through the all-encompassing lens of the conceptualizing mind, Surrealists sought to apply the new insights of Sigmund Freud to what went on in the psyche. Thus freely associated objects appeared in ways that challenged conventional seeing, while celebrating the powers of the unconscious to induce awareness of inner fears and wishes.

If Cubism and Surrealism displayed inner experience, Expressionism distorted outer experience through the unnatural deployment of color, anatomy, and overall facture to demonstrate the perilous aspects of the human condition. Here, the disintegrative aspects of Cubism and Surrealism found their most extreme demonstration.

Underlying all these modernist styles was the idea and practice of Abstraction—from the Latin *abstrahere*, to take away. That reduction of natural reality to essential structures led to the creative distortion of both space and time. The simultaneous presentation of sequential events thus required montage arrangements in which the entire history of an event was depicted in one work, rather than just single episodes. Both Rivera and Benton were ingenious in their uses of this kind of semiabstraction as a representational technique, as was Simka Simkhovitch in his 1938 mural sponsored by the Treasury Section of Painting and Sculpture (Section) *Pursuits of Life in Mississippi*, for the Jackson post office and courthouse.[9]

Beyond semiabstraction was pure abstraction, or nonobjective art, in which all reference to the natural world was rejected for the careful arrangement of colors and forms on a flat surface. This was the logical conclusion to modernism's reductive vision, though one notes that very few artists remained at this level for long. Mondrian is the exception; Picasso and Stuart

Davis the rule, since their work was always referential, even if that meant using only one legible word to define the identity of an otherwise abstracted image.

These modernist influences, muted as they often were and mixed in with bias toward Regionalism and the American scene, can be found in the work of Mississippi artists of the New Deal era. They can also be found in some of Eudora Welty's photographs.

A far stronger factor in Mississippi art of the 1930s is its emphasis on African Americans. These works might be seen as forms of social realism today in two senses of the phrase. The first is self-evident: how blacks were perceived by whites during the 1930s. The second refers to the New Deal's political realism of not directly challenging the conventions of southern segregation, while making it a firm policy not to exclude blacks from its relief programs.

Among the New Deal's many achievements was the integration of blacks and women,[10] along with members of other minorities such as Native Americans, Hispanics, and Asians, into the work force—especially into the ranks of artists employed in its cultural programs. It would certainly seem that there were few black artists to employ in the state or the South. In March 1935 there were only five African American artists on relief in the entire southern block of states. The WPA/FAP programs also made a serious and often quite successful effort to research and document black culture and to employ black writers and scholars. In 1936 a Negro Affairs section of the Federal Writers' Project was established, with faculty from Howard University participating, to integrate the role of blacks in the states into the American Guide Series.[11] It also undertook the documentation of slave narratives. Similarly, the Federal Music Project recorded African American regional music, spirituals, work songs, and folk music and the Federal Theatre Project produced a number of plays with all-black casts. As Federal Art Centers developed, a number were established in black communities, the most famous being that in New York City's Harlem.[12]

Since the New Deal emphasized African American history and culture, it can be assumed that white artists found it comfortable to work within that context of historical research and tolerance. There is also evidence—mostly found in their work—that some of these white artists were inevitably influenced by old attitudes and stereotypical thinking.

ART IN MISSISSIPPI DURING THE 1930S

It is of some interest to note that the Mississippi artists mentioned here ranged in age from sixty-four to eighteen in 1935, when the New Deal projects were established. Their average age was thus about thirty in the mid-1930s. They are discussed here in a sequence from the most academic in style to the least. One of the oldest at forty-five, Marie Hull, leads, the Anderson brothers place at the center of the chronological spectrum, while two of the youngest, John McCrady and William Hollingsworth at twenty-four and twenty-five, respectively, follow after. So arranged, their work can be seen clearly in the context of the developing visual culture of the era—and other Mississippi artists can then be constellated around the stylistic poles they establish.

Marie Atkinson Hull (1890-1980) was by far one of the best trained and most widely traveled of the group, and was typical of her academic generation's solid craftsmanship and stolid approach to her subjects. She studied at the Pennsylvania Academy of the Fine Arts and at the Art Students League with other academic artists such as Frank Vincent DuMond. She even showed a work at the Spring Salon at Paris in 1931. Although she lived to be ninety and developed during the second half of her life as an artist beyond the limitations of her "traditional" period which extended from 1912 to 1940, her work during the New Deal era is an honorable example of its kind. One thinks of her richly colored portraits such as *Sharecropper* (1938), or of a still life painting like *Lilies* (1930), as comparable to the work of artists such as Alexander Brook, Leon Kroll, and Kenneth Hayes Miller. Her subjects exist in real space and time and exude a natural dignity unembellished by overt iconic attributes or covert stylistic commentary, as do her portraits of African Americans, such as *Melissa* (1930).

In this sense, the work of Karl Wolfe (1904-1985) is similar, if somewhat more European in style than Hull's—as his *People in Church* of about 1936 would indicate.

Simka Simkhovitch, mural in the James O. Eastland United States Courthouse at Jackson, Mississippi, 1938. Courtesy of Mississippi Museum of Art, Jackson.

William Hollingsworth, *Three in a Wagon*, 1941. watercolor on paper. Collection of Mississippi Museum of Art, Jackson. Bequest of Jane Oakley Hollingsworth. 1987.018.

It is of some interest to know that Marie Hull's 1936 portrait of ex-slave John Wesley Washington, *An American Citizen*, was exhibited at the National Exhibition of American Art at New York in 1937. Several other Mississippi artists—Caroline Compton, Leon Koury, and Helen Jay Lotterhos—were also included in these important exhibitions. They began in 1936, with a display of work from forty-six of the then forty-eight states installed from May 18 to July 18 at the International Building in Rockefeller Center, New York. The second and third exhibitions followed in 1937 and 1938 at the American Fine Arts Society Galleries. The number of works to be shown was determined by population, with Mississippi allocated ten paintings and two sculptures based on this criterion. These national exhibitions were conducted by New York City's Municipal Art Committee and were partly sponsored by the WPA/FAP. They anticipated those at the New York World's Fair in 1939-1940, in one of which William Hollingsworth partici-pated. They provided an enormous stimulus to the national art scene. Each state was required to establish a competition or jury to select the works. Unfortunately, no attempt has been made since to revive these democratic exhibitions, which gave the artists selected both local and national recognition.[13]

The Anderson Brothers—Peter (1901-1984), Walter Inglis (1903-1965), and James McConnell (1907-1998)—the three sons of Annette McConnell and George Anderson, have made a lasting contribution to the visual culture of Mississippi. Their mother founded an artists colony near Ocean Springs in 1918, and ten years later Peter established Shearwater Pottery there.

They were all employed on the PWAP in 1934. James designed two tile murals on the themes of fish and birds which Peter glazed and fired, and Walter created six oil-on-canvas murals. Both projects were later installed in the school at the artists' expense.

Of the three brothers, by far the most interesting as a painter and graphic artist was Walter. He possessed a rare quality of vision that made him an ideal painter of nature. He spent most of his adult life, despite a serious mental breakdown in the late 1930s, drawing and painting birds and their habitats. His training at the Parsons Institute of Design in New York

and the Pennsylvania Academy of the Fine Arts gave him a firm technique, and his artistic visions, no doubt intensified by his mental condition, gave him a unique insight into the structures and emanations of natural beings. In this his art is similar to that of other visionary painters, such as Vincent Van Gogh's dramatic renditions of natural fields of force and Charles Burchfield's pantheistic expressions of the aura of living things.

John McCrady (1911-1968), of all these artists, would seem the most typical 1930s Regionalist. His *Political Rally* (1935) has all the tension and exuberance of a Reginald Marsh crossed with John Steuart Curry, and its subject anticipates Thomas Hart Benton's rallies in his Missouri State Capitol murals. Indeed, Benton's stylistic vocabulary can be found in McCrady's stylized landscapes and skies, while the elevated point of view of his 1939 *Oxford on the Hill* is pure Grant Wood.

In 1939 McCrady was commissioned to paint a Section mural in the post office at Amory, Miss. Depicting the town in 1889, he managed a well-planned, tripartite composition, with a perfect rendition of a Tom Benton locomotive augmenting the clouds with its puffs of steam. He also managed to paint a town that never was. Indeed, it is perfectly staged for public inspection, its vagrant ladies and gentlemen arranged in three impeccably designed groups before buildings worthy of their station. This blatant social idealism was typical of many Section murals and of a general sense that the past was "usable" to create a model to which the Depression-riven present might aspire.[14]

By far his most original and contentious images are those depicting black spirituals, such as *Judgment Day* (1938) and *Heaven Bound* (1940), with his most famous being *Swing Low, Sweet Chariot* (1937). The open door of an old African American's cabin reveals a deathbed scene, while the Bentonesque sky above the building opens in baroque splen-dor to reveal a swarm of winged angels and devils—and a chariot—in contention for the soul, which is seen floating up from the chimney. Although not exactly surreal in any sense Salvador Dalí might recognize, it comes as close as one might find to such an "a-naturalistic" and multivalent stylistic vocab-ulary in Mississippi.

Indeed, McCrady was a very religious man, and he did not like being compared to the more outré, not to mention risqué, aspects of Surrealism.[15] His disavowal shows his sense of historical analogy with the allegorical traditions of the past. He well understood that art attempting to paint anything other than the most literal rendition of visual experience must violate the canon of space and time, not to mention gravity.

McCrady's images of winged blacks in his series depicting spirituals made him famous. They also raised questions about his attitude toward African Americans. The *Daily Worker* in New York accused him of "racial chauvinism" on the occasion of an exhibition of these works. This seems to have driven him into a midlife crisis at the age of thirty-five and suggests that painting blacks then and later was a challenge. His best intentions concerning black rituals enacted in churches, such as *Heaven Bound*, in which a devil figure tempts the congregation with booze and money, could not escape the stereotypical regional attitudes displayed in a painting such as McCrady's *Judgment Day* (1938). In contrast to the starkly direct woodcuts of Lalla Walker Lewis (born 1912), created in 1935, which show black farm workers laboring at plowing and seeding under the supervision of a mounted foreman, McCrady's images of naked blacks chasing a devil's temptations seem more social satire than social realism.

William R. Hollingsworth, Jr. (1910-1944) was by far the most stylistically freewheeling of the younger artists. Working for the most part in watercolor and graphic mediums, he approached Expressionism with his distortions of form and figure, especially in his 1943 work *It Was Cloudy when Evalina Married*.

Hollingsworth was never employed by the WPA/FAP, but he worked for the Federal Emergency Relief Administration for five years, resigning in 1939 to devote himself full time to his art. In late 1940 he was included in an exhibition for National Art Week, a highly successful attempt to raise awareness for art across the country and to promote its sale.

In 1939, no doubt hoping for a Section commission to tide him over, he submitted a study for a post office mural on the theme of "the southern negro." It displayed a strong design and followed Rivera's and Benton's montage style,

which allowed the simultaneous depiction of events in contiguous spaces.

Indeed, Hollingsworth was interested in modernist art of this time. In 1941 he traveled to New Orleans to see an exhibition of Picasso's work, remarking dryly in his journal, "no danger of any immediate influences." An oil painting of the same year, titled *Fear*, belies the statement and is a fine if overly expressive attempt to emulate Picasso's early Cubist style. By 1943, however, it is clear that Picasso's *Guernica* influenced him, although the artist had little time left to develop his work before his tragic suicide in 1944.

To return to Hollingsworth's Cubist-influenced mural study for the Section, one sees to the left a couple flirting while a boy regrets a surfeit of watermelon. In the middle, three generations are energetically off "goin' fishin'," while the stay-at-homes play craps. To the right a woman washes clothes while a man sorts a pile of sugar cane, perhaps seeking the perfect reed from which to make a flute. All three events are integrated into a fluidly coherent yet carefully compartmentalized space.

It must be noted, however, that the subject matter of this panel, like some aspects of McCrady's work, was hardly integrated with the New Deal's policy toward African Americans, nor with today's views of racial caricature. While Hull depicted her black subjects with dignity and sensitivity, Lewis illustrated their condition with relative objectivity, and McCrady took a generally positive view of their religious and musical culture, Hollingsworth's emphasis on images of watermelon eating, laziness, and sexual innuendo bespeaks stereotypes that would hardly be acceptable today. They obviously were not to the Section's jury, to whom a touch of Cubism was well in keeping with what is found in many of its commissions—including several painted in Mississippi—but which would and did reject any hint of racism, however benign or unconscious.

The era of the 1930s saw a wider range of reference manifest in the arts than can be found earlier in the century—or subsequently. Modernism after the Armory Show of 1913 was one of many competing aesthetics at odds with traditional art. As almost any Mississippi artist of the period would have noticed, modernism tended to constrict rather than expand the artist's

William Hollingsworth, *Elevator, Tower Building*, no date. oil on board. Collection of Mississippi Museum of Art, Jackson. Bequest of Jane Oakley Hollingsworth. 1987.065.

John McCrady, *The Shooting of Huey Long*, 1939. egg tempera and oil on canvas. Collection of Mr. and Mrs. Keith C. Marshall, New Orleans, Louisiana.

subject, which became more communal and democratic. The stylistic innovations of European modernism were employed as tools for the expansion of the artist's traditional subjects (as Rivera and Benton employed Cubist montage) before they came to serve the purely subjective agenda of Abstract Expressionism after 1945. Further, murals and photography, promoted by the early modernists, preempted the conventions of traditional art. In sum, the fledgling modernist tradition, barely underway in this country during the 1920s, found its penchant for abstraction and individual expression co-opted for social purposes during the 1930s.

Here it is worth remembering that the artists, government officials, and general public during the 1930s did not see the world through the same ideological and psychological lenses we perceive public and artistic reality today. They predated the Second World War, the Holocaust, the Cold War, the Civil Rights Movement, the international counterculture of the late 1960s, and perhaps most important, the politicizing and psychologizing of our culture. The latter sensitized the public to the ethical dimensions of politics, the complicity of interpreters in the cultural situation, and the capacity of art to abstract universal experience rather than just narrate events. Life and art were seen more literally during the 1930s, will power predominated over the new notion of an "unconscious," "ordinary people" were valued, and there was a basic bond of trust between those people and the government. What *art* meant then—especially government-sponsored art in a rural state like Mississippi—and what it signifies seventy-odd years later, are quite different things.

It was the New Deal's greatest achievement to provide a nurturing environment in which this complex cultural transition might take place. It refused just to procure masterpieces, choosing also to promote free expression. As a result, paradoxically, few raw political references can be found in American art of the period. Thus the explicitness of Paul Cadmus's *Herrin Massacre* (1940), which shows strikebreakers killing workers with pitchforks, or even McCrady's *The Shooting of Huey Long* (1939), which shows both assassin and victim pierced with bullets, is rare. Most FSA photographs, while capturing rural reality, stressed the indomitable

(if harried) nature of the people, not their abject condition, as did John Steinbeck in *The Grapes of Wrath*, which was strongly influenced by FSA images. Of the work in *Art Front*, the radical publication produced by New York's Artists Union, only about 25 percent can be construed in any way as protest art. Artists of whatever ideological persuasion, surrounded by the effects of the Depression, chose to paint either what was imagined to have been (as McCrady did in his Section mural), what ought to be (as Hull did in some of her portraits), or, as many others in Mississippi chose to do, to paint what could be seen within traditional limits or through the tentative freedom of the new modernist styles—as did Hollingsworth. Walter Anderson achieved a parallel vision within the implosion of his mental state: he saw nature already abstracted.

But the New Deal programs provided a context in Mississippi and across the country in which artists might survive as artists and develop beyond their traditional origins. As we have seen in Mississippi, traditionalism gave way to modernism in subtle and indirect ways, even as the range of visual experience and artistic enterprise contracted from the exterior to the interior world. Cubism, Surrealism, Expressionism, and Abstraction became channels for individual creations that won out over an American scene, however limned or photographed.

EUDORA WELTY'S PHOTOGRAPHS OF PEOPLE

Welty loved her Rolleiflex, with its ground-glass viewfinder, over the box cameras she had first used, because it allowed her to frame her view as her fingers had earlier.[16] When asked about the quote from her story "A Memory" (see epigraph above), she said that "a frame is fundamental" to both a photograph and a story, since it "frames your vision," although she did not rely on her photographs for her stories, since "memory is far better."[17]

More intriguing was her desire to "wrest" from what she saw in the frame of her fingers or viewfinder a "secret life" in people she could situate, as in a story. Her creative sensibility would seem to be divided between a certain empathy for her subjects and a genteel voyeurism that she left essentially to her imagination. That, however, applies only to her stories, since she said that photography was different from stealing

a moment's spirit or soul. "We steal spirits and souls if we can, and in love and devotion, what we do but pray: keep this as it is, hold this moment safe."[18] She also points out that "writing fiction is interpretive" since there is "no interpretation in a photograph."[19]

One can argue that the selection of her subjects was indeed an interpretive act. Welty felt strongly that Walker Evans "deliberately posed" his subjects and that her pictures "were taken in sympathy, not exploitation." Further, she let her subjects go on with what they were doing and composed the pictures later by framing or cropping them in the developing process.[20]

Nevertheless, Welty was drawn to the peculiar even if she was not Diane Arbus in fundamental sensibility. It is, therefore, hard to ponder her photograph *Delegate, Jackson*,[21] which shows a corpulent, uncorseted matron with a veritable cascade of ribbons and cockades adorning her left side, without thinking of that patriotic young boy photographed by Arbus.[22] Indeed, throughout her photographic oeuvre there are any number of images that can more or less be related to her stories of the era, where oddities abound.[23]

We might begin with the freak show at the state fair. When asked if the carnival folk in her stories could be related to Diane Arbus, she made it plain that she thought Arbus's photographs "violated her subjects' privacy." Welty explained that as part of her duties as the WPA's press agent, she would travel to the state fair and set up a booth promoting the WPA's activities. In her time off she would then explore the fair's attractions with her camera, noting correctly that she photographed the posters not the freaks—and never saw a geek.[24] The posters of a headless girl, a mule-headed woman, Siamese twin calves, a sex show, and shots of a state fair parade are of documentary interest—although it is clear that her stories profited from being in their vicinity.[25]

Also peculiar are a series of photographs of young black women dressed for a pageant of birds. They are in their Sunday best with elaborate wings attached to their backs and sleeves. These pictures are posed, since Welty was not able to take shots of the actual pageant—which was a private fund-raising project the women's church was circulating

Eudora Welty, *Delegate, Jackson*, post 1936. Eudora Welty Collection – Mississippi Department of Archives and History.

about the state so it could buy a new piano. Following are lyrics to the sadly revealing protest song—indicative of black culture of the 1930s—which the women sang as they marched around the church:

And I want TWO wings

To veil my face,

And I want TWO wings

To fly away,

And I want TWO wings

To veil my face,

And the world can't do me no harm.[26]

Just as these photographs suggest the sometimes bizarre characters and status of blacks in her stories, the great majority of Welty's photographs either reflect the more normal individuals and activities she wrote about, the life of poor folks of all races in Mississippi, or the modern styles of art just beginning to find acceptance. A 1935 photograph of an elderly black woman titled *A woman of the 'thirties, Jackson,*[27] a sensitive portrait of the woman, is typical of many such images in Welty's oeuvre. It confirms her testimony that she was not trying "to say anything about myself in the pictures of people [but] trying to say everything about them. I was just the instrument."[28] This seems especially true of her charming photograph *Making a date, Grenada,*[29] which captures two African Americans in flirtatiously torqued poses and oblique smiles halfway between surrender and flight.

Another arresting portrait is *Bootlegger's House,*[30] which shows a plump, smiling African American woman brandishing an ice pick at the camera, with its shadow striking across the woman's chin—one of those happy accidents every photographer treasures. Similarly, the first photograph in the *Holiness Church* series,[31] which shows a hieratically posed African American women sitting among a group of Sunday School children, has just enough glare coming in the window over her left shoulder to suggest something approaching glory.

Eudora Welty, *A woman of the 'thirties, Jackson,* 1935-1936. Eudora Welty Collection – Mississippi Department of Archives and History.

Another shot from this series seems almost abstract in its arrangement of the white dresses.[32] Indeed, a number of her photographs have an abstract quality, such as *Political Speech*,[33] in which we see a group of people sitting on the grass with a sleeping child in the foreground—but we see nothing of the occasion they are attending. In both these photographs the subject and the figures are abstracted in different senses of the word into an organic visual composition, more than a narration.

Geometric compositions are also to be found. The most striking is that of *Washwoman*,[34] where the figure is set in a complex frame of lines and ovals that creates a rigid world around her. The eye focuses on the woman who is resting after her work. She seems to be spreading out her apron, and the ground line of the porch is continued through the apron and the shadow of the tire under the tree to the right. The woman and her wash are framed by the porch columns, and the tilted rectangle takes on its own life separate from the washtubs that lead the eye out past the tire to the wheel of the car across the street. It is by far her most complex linear composition and sets up a certain shifting of planes that can also be found in her stories. Another image, *Chopping the fields, Warren Co.*,[35] shows a woman with a hoe that is exactly parallel to the horizon. So although these may be "snapshots" to Welty, they show some evidence that all those years of finger framing the mysterious world and its inhabitants taught her something of the structures underlying a good design. At the very least, the instincts of her eye can be discerned.

It is only in hindsight that we see her social realist eye in the strict FSA sense. An image showing a black man entering a theater through a door labeled Colored Entrance,[36] along with her shots of the unemployed in New York City,[37] makes the point as well as any arrangement of people and signs taken by Dorothea Lange. *Courthouse town, Grenada* of 1935,[38] with its bleak row of shops and signs seen from a distance, is similar to views by Walker Evans. But for Welty, recording Depression iconography was not her primary goal; she was interested in people and attracted to places such as old homes, churches, and graveyards where she believed their spirits had been or were now housed.

Eudora Welty, *Sunday school, Holiness Church, Jackson*, 1935-1936. Eudora Welty Collection – Mississippi Department of Archives and History.

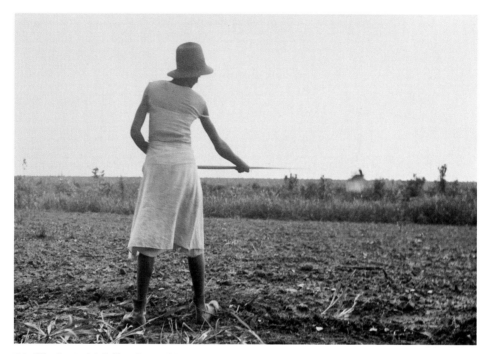

Eudora Welty, *Chopping the fields, Warren Co.*, prior to 1935. Eudora Welty Collection – Mississippi Department of Archives and History.

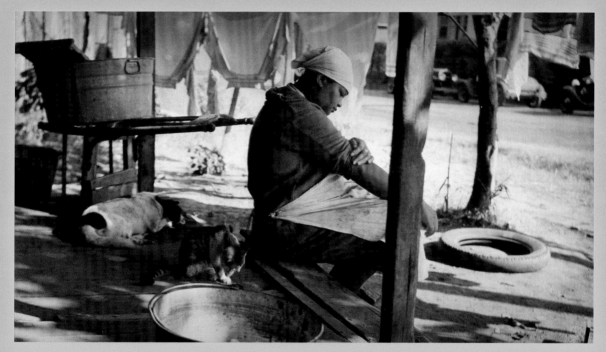

Eudora Welty, *Wash day, Jackson*, prior to 1935. Eudora Welty Collection – Mississippi Department of Archives and History.

Eudora Welty, *Courthouse town, Grenada*, prior to 1935. Eudora Welty Collection – Mississippi Department of Archives and History.

EUDORA WELTY'S PHOTOGRAPHS OF PLACES

Lincoln Kirstein, in a magisterial essay, noted that "the puritanical eye of T. S. Eliot would be sympathetic to the puritanical eye of Walker Evans."[39] In practice, this meant that Evans knew perfectly well how to pose a church—head-on with the façade parallel to the picture plane. For Evans, form was more important than context, so buildings of any kind were almost always seen head-on; diagonal views were achieved as long as the pattern created was frontal.[40]

One of Welty's more striking images of a place is that of a rectangle of classical Corinthian columns with small trees sprouting from their tops. It is the portico of Windsor, a destroyed plantation house, standing stark and viewed obliquely on a knoll; her shadow is seen in the foreground peering into her camera. Compared to Evans's frontal view of *The Greek Temple Building* in Natchez, Miss.—which looks like an eighteenth-century steel engraving[41]—Welty's photograph evokes all sorts of associations, from the Greeks' Parthenon to *Gone With the Wind*.[42]

Welty would not be able to imagine the task of rigidly framing buildings when they posed themselves so dramatically and organically in their landscapes, nor could she imagine a landscape that was not an image of wildness. Her *Confederate Veterans Meeting in a Park* is a long view of a tangle of trees soaring up and across the sky and above the elderly men sitting under their protection.[43] Most of her other landscapes were of tangled roots, vines, and thickets.[44]

Her views of churches are not of soaring, heaven-touching structures but of worn temples somehow embracing the graveyard's earth. Here, a superb example is her *Country church, Church Hill (near Natchez)*,[45] with its low roof and rounded edges surrounded by the graves of generations of worshipers. This is also true of her views of other, more conventional-looking churches.[46] They stand there, sometimes frontal, in a landscape context of which they are a part, but they have an eerie life of their own, partly due to their lack of repair but most often to how they are situated in their environment. The wooden *Catholic Church* seems to float above the ground, while the *Country church* sinks into it.[47] They seem rooted to and somehow askew in the earth; in contrast, Evans is always thinking of sharp outlines and firm foundations.[48]

What really attracted Welty was not so much the churches but their cemeteries, which had "a sinister appeal." She also felt that "Mississippi had no art except in cemeteries," which is true if she meant only sculpture—her region possessed little art that stirred the imagination on so deep a level.

It is plain that she was fascinated by carved tombstones, the more elaborate the better; she especially liked one which depicted a child reposing within a seashell.[49] Another with a more ironic aura is that of a politician's grave stele, which contained a portrait bust of the honorable gentleman with a scroll inscribed "True to the Public Trust."[50] And amid a choir of conventional if rather eerie, weather-stained angels, the most sinister of all were several views of a long-neglected, unadorned tomb with its stone slab ajar.[51]

EUDORA WELTY'S EXPRESSIONISM

While we have seen elements in Welty's stories and photographs that can be related to the various styles of American art during the 1930s—American scene, Social Realism, Cubism, Abstraction, Surrealism, Expressionism—no single style seems overt in her work. Covertly, however, a case can be made for her being an Expressionist.

She all but admits this in the second half of the passage quoted in the epigraph about her projecting the world through the frame of her fingers: "From any observation I would conclude that a secret of life had been nearly revealed to me—for I was obsessed with notions about concealment, and from the smallest gesture of a stranger I would wrest what was to me a communication or presentation."

While such a method of prompting creativity might seem closer to Surrealist "psychic automatism" or free-associating with an image, there is very little in her work that resembles Surrealist juxtapositioning in order to exploit a striking contrast of images. True, there is a penchant for a certain macabre theatricality, especially in her two stories about carnival freaks[52] and her photographs of women as birds or tombs ajar. On the other hand, her need to find her own take on the world and

to prompt her own personal interpretations of its "secrets" is the formative condition through which her visual and verbal imagery came into being. One senses in some of the stories (about couples sacrificing their bedding to save the crops, finding false news of a shooting somehow arousing, or one murdering the other only to fall into a hallucination of New York opportunities) a young woman coming of age through her imagination in defiance against the inhibitions of her social situation and personality.[53] Indeed, she admits that holding a camera in front of her "may have been a shy person's protection." [54]

Here, her most famous and first published story of the 1930s, "Death of a Traveling Salesman," is revealing. The salesman, who is recovering from influenza and suffering from an irregular heartbeat, gets lost in his car on a country road. He reaches a dead end, the brakes fail, and the car rolls into a ravine. He seeks help at a nearby house where a woman lets him in. The man of the house pulls the car back to the road. He asks to stay the night, is offered a drink of moonshine and dinner, and sleeps on the hearth. Later at night, he leaves all his money for them, walks to his car, and dies suddenly.

What brings this story to life—what makes an event of these anecdotes—is Welty's narration of the salesman's hallucinatory view of his surroundings. He feels lost while driving, feverish and unwell, thinks of his nurturing grandmother, is surprised by the irregular racing of his heart, seems utterly passive when his car slips away from him, sees the woman first as old and squatting at the hearth, thinks of sleeping with her, then she reminds him of his mother, later he sees her as the young, pregnant wife of the man who saved his car. He feels left out of life and seems to be experiencing a fantasy of the one he wished he had lived. The reader slowly comes to understand this, that the story is told in two times: the dozen hours of the story and the putative lifetime of its protagonist. The narrator breaks through all his old inhibitions and repressions and has the salesman express to himself the life he never had. In doing so Welty almost reverses the old cliché that a person sees his life history in a flash at the moment of death. The salesman regrets not having a family, yet he seems somehow fulfilled by the "fruitful marriage" into which he had stumbled at the end of his road.

The Expressionist sensibility distorts outer happenings through the unnatural deployment of appearances and events to demonstrate aspects of the human condition which a more straightforward rendering would obscure. It breaks through reticence to reveal the insistent; it ignores time and expresses it in the open space of art.

Welty says as much in her autobiography *One Writer's Beginnings*:

My temperament and my instinct had told me alike that the author who writes at his own emergency, remains and needs to remain at his private remove. I wished to be, not effaced, but invisible – actually a powerful position. Perspective, the line of vision, the frame of vision – these set a distance.[55]

When Eudora Welty was taught to frame the subject of a painting with her fingers—and when she found to her delight that her Rolleiflex did this automatically—she learned how to turn the "emergency" of time into a permanent, two-dimensional space. Actions pregnant with all sorts of meanings could be controlled, contained, obtained, and ultimately expressed in a secure place of her own creation. "I am," she said, "a writer who came of a sheltered life. A sheltered life can be a daring life as well. For all serious daring starts from within." [56] By photographing the actions of others, she showed what they experienced so the viewer would be able to match her image to their own life and values. But by writing of the actions of others, she could go further: becoming an "omnipotent narrator" who knew everyone's most intimate thoughts —which of course were hers—and made art out of them so others might validate their own experiences and know that they also were human.

Eudora Welty, *Ruins of Windsor, near Port Gibson*, post 1936. Eudora Welty Collection – Mississippi Department of Archives and History.

Eudora Welty, *Country church, Church Hill (near Natchez)*, 1935-1936. Eudora Welty Collection – Mississippi Department of Archives and History.

NOTES

1 Eudora Welty, et al., "A Memory," in *Eudora Welty: Stories, Essays, & Memoir* (New York: The Library of America, 1998), 92-93. See also her commentary on this, which indicates its autobiographical character, in her memoir *One Writer's Beginnings*, op. cit., 931-32.

2 Eudora Welty, et al., *A Curtain of Green, and Other Stories*, in *Eudora Welty: Stories, Essays, & Memoir*, 1-171.

3 The titles are, respectively: "Lily Daw and the Three Ladies"; "A Piece of News"; "Petrified Man"; "Keela, the Outcast Indian Maiden"; "Why I Live at the P. O."; "The Whistle"; "Clytie"; "Old Mr. Marblehall"; "Flowers for Marjorie"; "A Curtain of Green"; "A Visit of Charity"; "Death of a Traveling Salesman"; "A Worn Path." The manuscripts were not dated. See Suzanne Marrs, *The Welty Collection: A Guide to the Eudora Welty Manuscripts and Documents at the Mississippi Department of Archives and History* (Jackson: University Press of Mississippi, 1988), 30-33. Marrs also wrote a useful account of Welty's photographs on 77-91.

4 See Eudora Welty, et al., *Eudora Welty: Photographs* (Jackson: University Press of Mississippi, 1989), xvii.

5 For statistics about Mississippi artists, see *Final Report of the Public Works of Art Project* (Washington, D.C.: U.S. Government Printing Office, 1934), 54, and P. M. Houser, *Workers on Relief in the United States in March 1935 - Volume 1 - A Census of Usual Occupations* (Washington D.C.: U.S. Government Printing Office, 1938), excerpted in Francis V. O'Connor, *Federal Support for the Visual Arts: The New Deal and Now* (Greenwich, Conn.: The New York Graphic Society, Ltd., 1969), 190-203. For information about New Deal projects in Mississippi in regard to African Americans, see W. F. McDonald, *Federal Relief Administration and the Arts: The Origins and Administrative History of the Arts Projects of the Works Progress Administration* (Columbus: Ohio State University Press, 1969), passim.

6 Mrs. W. F. [Lucile] Henderson to Olin Dows, from two letters dated September 15, 1935, Archives of American Art, TRAP, roll DC28.

7 In 1935 Mississippi did have a flourishing Federal Project No. 1, which nationally supported artists, theatrical folk, musicians, and writers. It was established within the WPA's Division of Women's and Professional Projects, which operated under the direction of a distinguished Mississippi woman, Mrs. Ellen Woodward, who was the daughter of Senator W. V. Sullivan and the wife of Judge A. V. Woodward. She had been a state legislator from 1926 to 1928 and active in a number of social service agencies. She was also a close friend of Mrs. Eleanor Roosevelt. But despite her connections to the state and the New Deal administration, the dearth of actors and visual artists—not to mention the national uproar over the liberal policies of the Federal Theatre and Art Projects—tended to leave local support directed toward less politically controversial areas, such as the Federal Music and Writers' Projects. Consequently, the WPA Federal Art Project did not develop to any extent in Mississippi until 1939—the year the Theatre Project was terminated and everything else was under state control. Then it established three community art centers. These provided an outlet for Mississippi artists in Oxford, Moorhead, and Greenville, with the Delta Art Center in the latter community being the most active.

8 Welty, et al., *Eudora Welty: Photographs*, xxv. Welty's employment records when she was on the WPA as a publicist indicate that she was so employed from June 24 to November 15, 1936. This conforms to her own memories: "I believe 1936 was the year I sent my first story out, and it was published that year. Our [WPA] office was disbanded with the re-election of Roosevelt. . . . We were through the day he won. We didn't know that was going to be the end, but it was. So I was working then, and the same year I had a story. I don't have a very good memory by years, but that coincided." Quoted from interview by Bill Ferris in *Images of the South: Visits with Eudora Welty and Walker Evans, Southern Folklore Reports*, No. 1, (Memphis, Tenn.: Center for Southern Folklore, 1977), 15. This would mean she was on the WPA for less than six months in 1936, yet her photographs date before that and through the late 1930s. Further research here is needed to establish which of her photographs were created on the WPA and which were not.

9 The final report of the Treasury Section of Fine Arts dates this mural 1938. See also Janet Marqusee, *Simka Marqusee Simkhovitch (1893-1949): Paintings* (New York: Janet Marqusee Fine Arts Ltd., 1987). Like most of the twenty-five artists who did Section murals in Mississippi, Simkhovitch lived out of state, in Greenwich, Conn.

10 Seventy-five percent of the PWAP artists in Mississippi were women. Of the forty-two artists on relief identified in 1935, 64 percent were women, and about 20 percent of Section commissions in the state were won by women. It is unclear how many women worked for Mississippi's WPA/FAP.

11 For the results of this, see Jerre Mangione, *The Dream and the Deal: The Federal Writers' Project, 1935-1943.* (New York: Avon Books, 1972), 255ff.

12 See Francis V. O'Connor, ed., *Art for the Millions: Essays from the 1930s by Artists and Administrators of the WPA Federal Art Project* (Greenwich, Conn.: The New York Graphic Society, Ltd., 1973) "Community Arts Centers," 208-27.

13 For a discussion of these exhibitions, see Marchal E. Landgren, "A Memoir of the New York City Municipal Art Galleries, 1936-1939," in Francis V. O'Connor, ed. *The New Deal Art Projects: An Anthology of Memoirs* (Washington, D.C.: Smithsonian Institution Press, 1972), 269-301.

14 For more on this idea, see see A. H. Jones, "The Search for a Usable American Past in the New Deal Era," *American Quarterly*, Vol. 23, No. 5 (December 1971), 710-24.

15 See Keith Marshall, *John McCrady: 1911-1968* (New Orleans: New Orleans Museum of Art, 1975), 18.

16 Welty, et al., *Eudora Welty: Photographs*, xvi.

17 Ibid. It is clear from her response that the finger framing was autobiographical and not part of a fiction.

18 Quoted in Charles Mann, "Eudora Welty, Photographer," *History of Photography*, Vol. 6, No. 2 (April 1982), 147.

19 Welty, et al., *Eudora Welty: Photographs*, xvi.

20 Ibid., xvii, xxvi, and xxviii.

21 Eudora Welty, et al., *One Time, One Place* (New York: Random House, 1971), 105. Her photograph, *Baptist deacon, Jackson*, plate 87, which shows an elderly moustached African American dressed in a white suit, is also striking for its strangeness.

22 Diane Arbus, et al., *Boy with a Straw Hat Waiting to March in a Pro-war Parade*, in *Diane Arbus: An Aperture Monograph* (New York: Aperture, 1972).

23 See Patti Carr Black, *Welty* (Jackson: Mississippi Department of Archives and History, 1977).

24 Welty, et al., *Eudora Welty: Photographs*, xviii.

25 Ibid., plates 77-80; 130-37.

26 For a detailed account of this first published in *The New Republic*, October 25, 1943, see Eudora Welty, *A Pageant of Birds* (New York: Albondocani Press, 1974). See also Welty, et al., *Eudora Welty: Photographs*, plates 100-103.

27 Welty, et al., *Eudora Welty: Photographs*, plate 1; dated 1935.

28 Ibid., xxviii. When Welty discovered that a person she photographed had never been photographed before, she would try to send that individual a print, xxv.

29 Welty, et al., *One Time, One Place*, 62.

30 Ibid., 65.

31 Welty, et al., *Eudora Welty: Photographs*, plates 104-7.

32 Ibid., plate 106.

33 Welty, et al., *One Time, One Place*, 83.

34 Ibid., 19. This photograph is also titled *Wash day, Jackson*.

35 Ibid., 11.

36 Welty, et al., *Eudora Welty: Photographs*, plate 82.

37 Ibid., plates 151-55. These photos were taken from a distance and capture the pathos of the crowd.

38 Ibid., plate 69.

39 See his essay, "Photographs of America: Walker Evans," in *Walker Evans: American Photographs* (New York: East River Press, 1975), 187.

40 See *Walker Evans: American Photographs*, op. cit., 138-55.

41 Ibid., 143.

42 Or "Gone with the Flood," if the title *Home After High Water* (which crops her shadow), given in *One Time, One Place*, 43, is correct. It is titled *Ruins of Windsor* in *Eudora Welty: Photographs*, plate 119.

43 Welty, *One Time, One Place*, 61. For other landscape photographs, see *Eudora Welty: Photographs*, plates 124-25.

44 Welty, et al., *Eudora Welty: Photographs*, plates 124-25.

45 Ibid., plate 123.

46 Welty, et al., *One Time, One Place*, 92-95.

47 Welty, et al., *Eudora Welty: Photographs*, plates 118 and 120.

48 And of making important works of art as an artist. See Evans's interview in *Images of the South*, where he never quite admits to having worked for the FSA and talks of himself as an "aristocratic" artist (36). For him, "formalism" has two meanings—design and class.

49 Eudora Welty, et al., *Eudora Welty: Country Churchyards* (Jackson: University Press of Mississippi, 2000), 79.

50 Ibid., 28-29.

51 Ibid., 91-92.

52 It is of some interest that one finds a number of references to these two stories in Leslie Fiedler's *Freaks: Myths and Images of the Secret Self* (New York: Simon & Schuster, 1978), where he describes Welty and Carson McCullers as "Southern Gothicists," 136.

53 For a trenchant discussion of the psychology of Expressionism and its relation to Surrealism, see Donald Kuspit, "Breaking the Repression Barrier," *Art Journal* 47:3 (Fall 1988), 229-32, esp. 229, 230: "The Expressionist impulse attempts to break the repression barrier, regressing the psyche towards an unstructured infantile condition of unrepressed wish and hallucinatory wish fulfillment. . . . It is in effect a desperate narcissism, a primitive idealizing tendency, involving the projection of a mythical integrity of self. . . . Expressionism and Surrealism overlap in their tendencies to automatism, with its abandonment of [psychic] criticality and censorship in order to articulate the [unconscious], but Surrealism has no intention of breaking the repression barrier. Surrealism wants to exploit it, rather than to break it."

54 *Images of the South*, 14.

55 Welty, et al., *Stories, Essays, & Memoir*, 931.

56 Library, Massey lecture, 948.